BOLO'BOLO

P.M.

BOLO'BOLO

P.M.

AUTONOMEDIA / ARDENT

anti-copyright @2011

Autonomedia
POB 568
Brooklyn, NY 11211-0568 USA

www.autonomedia.org
info@autonomedia.org

Ardent Press
info@ardentpress.org
ardentpress.org

Introduction to the Third English Edition

bolo'bolo 30 Years Later

bolo'bolo was first published in 1983 (German edition) and is reprinted here in its original form. After the crisis of the seventies, that had ended the post-war cycle, it was meant to show a plausible way out. Thirty years later the same crisis — with all its permutations — is still unresolved, and we're still looking for a way out. The basic questions are still the same: how can we find a way of life that is really sustainable, ecologically and socially? The limits of growth were already known thirty years ago, but climate change was a thing of the future, and looked preventable. Now climate change is a fact, and all we can do is try to mitigate its effects. At the same time, the divisions among the inhabitants of this planet have become deeper in a dramatic way. The richest ten per cent of the world population now own 85 per cent of its assets. The richest one per cent owns forty per cent of them. The poorer half of the world population earns only one per cent of the overall income, the other half, 99 per cent. In 1960 the richest fifth lived on an income thirty times higher than the poorest fifth; by 2000, it was already eighty times more.

No wonder the twenty per cent of the world population that live in relative comfort are defending their life style with fences, border patrols, wars. Refugees from poverty are dying in the Mediterranean every day. The area of the A-deal has become a

gated community, an antisocial fortress. But the price is high, the world has become a dangerous place, and life within or outside the comfort zone is getting precarious. The situation looks much grimmer than thirty years ago.

On the other hand capitalism has never been as discredited as now. The conviction that it doesn't work and should be abolished is the common sense of our times. (Is Michael Moore our new Thomas Paine?) This common sense is so overwhelming, that most people don't even bother to criticize capitalism any more, but rather invest their energies directly in finding ways out of it. According to a study of the BBC, only eleven percent of the world population thinks that capitalism works well. In France, Mexico and the Ukraine more than forty percent demand that it should be replaced by something completely different. There are only two countries, where more than one fifth of the people think that capitalism works well in its present form: the USA (25 percent) and Pakistan (21 percent).

Ideas already presented in *bolo'bolo* are part of a larger common sense now. Degrowth, the commons, transition towns, cooperatives, climate justice, are all aspects of a global way out of capitalism. Almost every day there is a new contribution to the pool of alternative ideas, and "old" voices are heard more prominently. More and more farmers seem ready for CSA (Community Supported Agriculture) and other schemes of direct producer/consumer cooperation. The re-ruralization of the world, which Vandana Shiva speaks about, is incompatible with capitalism (it is intrinsically non-profitable), but can at the same time be seen as a revitalization or resocialization of our cities. (Cf. New York City in the year 2400 in the Manhattan project) More and more people understand the concept of subsistence (*kodu*) as a practical way of organizing our social metabolism.

As Vandana Shiva points out, our "north-western" lifestyle is only possible for one out of seven billion people on this planet. The same view is shared by Hans-Peter Gensichen who uses the term *Armseligkeit* (an interesting German word, a combination of poverty and beatitude) describing a new global way of life based on a consumption of resources on the level of countries like Chile or Slovenia, sustaining "happiness" with half of the GNP of the US or Switzerland. Global household politics will be one of our next tasks, and it should be taken seriously. Gensichen bases most of his evidence on the experience of East German projects of local production, exchange and cooperation. Even the newcomers to the capitalist utopia seem to have seen enough. However Gensichen positions his proposals in a strictly global context.

Among the many initiatives that are being created at the moment, I want to mention sole-freiburg.de (life and solidarity). Their basic axiom sounds so simple, that it almost hurts: "We help each other, we contribute things or services according to everybody's possibilities for the benefit of others. We do not keep book on what is given or received." Imagine how horrible this must sound in the ears of market fetishists.

Even the "state" looks better now (not just because private capital looks bad), especially in its municipal or regional aspects (*tega* and *sumi*). There is no more talk of privatization at the moment, on the contrary. The privatization of the local electric supply was voted down in Zurich, a proposal to privatize the municipal catering system (for schools, or "meals on wheels") has no chance whatsoever. The tragedy of privatization is giving way to the happy endings of the comedy of the commons.

The actual state can be transformed and so become a ready and easy tool of transition. Transition towns are

emerging everywhere. Transition states, territories, provinces or regions could be the next step, up to a planetary transition "cooperative" of democratic states (*asa*). The expansion of public services can provide existential security for everybody and thus free us from the terrorism of waged work. As they can't we'll help them devalue their capital.

I can see three existing forms of organization of the emergent commons: a transformed state (*feno*), rural/urban subsistence (*bolo*), and an area of cooperative enterprises. All these forms have a long history, are based on inclusive, democratic structures and can function beyond the law of value. At the same time, their constituency is functionally different and will guarantee systemic stability.

I think the way ahead is getting clearer every day. At the same time, watchfulness is essential. There is no automatic escalator into a better future. Every step will require careful evaluation, collective organization and autonomous institutions.

<div style="text-align: right">P.M. May 5, 2011</div>

Introduction to the Second English Edition

"Apology," A Decade Later

According to the Provisional Schedule in the first English printing of *bolo'bolo* we should now all be living happily in *bolos*, traveling around the planet without credit cards or passports, enjoying hospitality everywhere, working some, playing some, sleeping some and not worrying about anything. Nation-states, armies, big companies, 9-to-5 jobs, poverty, hunger, car traffic, environmental pollution, etc., should be no more than dim memories of a past age of stupidity and mutual fear. No

such monsters as the USA, Russia or China should exist any more, but a patchwork of intentional regions (*sumi*) of maybe ten million inhabitants and the size of Pennsylvania, largely self-sufficient. Instead of nations there should be criss-cross cooperation between these regions, worldwide.

Now, if we look at the real year 1993, we couldn't be farther off schedule. Not only hasn't the Planetary Work Machine (or economy — state, private or mixed — as some prefer to call it) not dissolved, it's kicking and alive, killing to the left and to the right, imposing still lower levels of misery. We are further away from any conceivable Utopia than ever. Instead of paradise, 1991 brought us one of the most cynical wars ever (or shall we call it a punitive expedition?) to ensure that energy prices remain "reasonable" and under control. The Gulf War has proved once more that the Planetary Work Machine is really *one* Machine, not limited by nations, ideologies or property-systems. Energy, the blood of the Machine, is too vital to play funny games. The divisions (race, nation, wages, sex) are ours, not the Machine's.

Sure, the three Deals (A,B,C) are still in crisis, and this crisis has visibly deepened. In this respect, some of my predictions of 1983 turned out quite correct. (You're always right in predicting bad things, never when doing the opposite.) Of course there are more than just three types of deals between the Machine and us; reality is infinitely more complex. Actually, the use of computers has allowed the Machine to create and manage an "individual" deal for almost everybody. So the A,B,C deals are to be taken as simplified models, roughly corresponding to the amount of capital invested per worker ("organic composition," as we Marxists sometimes say).

So, a C-deal worker uses thousands of dollars, 10^3, a B-worker from tens to hundreds of thousands, 10^{4-5}, a C-worker, millions, 10^6. According to their responsibilities

(or risks for the Machine), qualifications, wages, prestige and lifestyle are tuned. The same holds for political systems (or procedures of legitimation): the higher the organic composition in a given area is, the more "democracy" and "human rights" you're liable to get. You're not going to frustrate workers with dictators and random arrests, if they can ruin equipment worth millions of dollars by just turning the "wrong" switch in a fit of "human error"... (We should keep such business-like considerations in mind when we talk about lofty ideals like freedom, democracy, rights and guarantees.)

Talking about deals in crisis, the most striking collapse in the decade since I first wrote *bolo'bolo* has occurred in what I call the B-deal: the classic industrial-worker deal, in certain areas managed in the form of socialism. The concept of an average organic-composition deal with "Taylorized" exploitation via relative surplus-value (productivity linked to worker's performance) seems to be definitely "out." Mass workers — thousands of people holding the same jobs and doing comparable chores — have proved to be too strong to be submitted to increasing levels of output. After having been a low-wage colony for A-deal regions, Eastern Europe became a liability for the Machine.

Perestroika and other palliative operations of readjustment couldn't bring the workers back to real work. So bankruptcy or self-devaluation is the only weapon left to liquidate a blocked situation. The new strategy seems to consist of "special economic zones," a form of A-deal pockets within "bankrupt" B-deal areas, that could utilize the accumulated cheap human capital (a Russian monthly wage corresponds to $ 12 at the moment I write this) and infrastructure of socialism. (This would be similar to the Japanese or Italian models, where the big companies with their "guaranteed workers" feed on thousands of low-wage sub-contractor firms.)

The dissolution of the classic B-deal doesn't mean that industrial production disappears or becomes unimportant. On the one side, industrial production is robotized and computerized: no job is comparable to another, and the link between physical work and actual output is indirect. On the other hand, low technological work (including cleaning, repairing and maintenance) is geographically or organizationally separated from end-production and submitted to conditions similar to what I call the C-deal (largely female, marginal work). The B-deal — of medium-high organic composition in medium-large production units paying medium "decent" wages to feed average working-class families participating in a regular modern lifestyle — is being dismantled as well in the West as in the East. While it's called Thatcherism or "de-industrialization" in the West and is treated as a purely "economic" affair, it appears as a real "change of system" in the East.

It seems that the B-deal will be pulverized between a few workers joining the A-deal and many more falling back to the manifold miseries of old and new C-deals. In the meantime B-workers are still there, fighting in many forms, from Brazil to South Korea, from Poland to China.

The current melt-down of socialism is analogous in many ways to the Chernobyl accident of 1986. The reactor got essentially out of control, because it was deprived of its cooling system. The crew was playing frustrated macho-games and tried to run the reactor much below security levels, in the same way you violate speed limits in a sports car. In the same fashion, the socialist factory-state had no extra cooling system, economy and politics being in the same basket. Any economic failure became another blow to political legitimation, which in turn was completely worn out by the mid-eighties. Unlike in the West — where you can blame, alternately, politicians *or* the economy if there

is a recession or there isn't enough money for social programs — all evils concentrated on the one and same elite until the social reactor got out of control. Seemingly solid states like East Germany, with a very effective police apparatus, disintegrated miraculously over night. The collapse of the regimes didn't mean a collapse of the Machine anywhere though, just a change of the type of management, a psychologically more refined way of running it. The one thing we can learn from this experience is, however, that if we are capable of undermining (*"substructing"*) the Machine thoroughly in one place, we don't have to worry too much about police or military repression. The experiences of Eastern Europe show that the concept of armed revolutionary struggle is out-dated, ridiculous and unnecessary, at least in industrially advanced areas. Social mass sabotage is much more effective.

At least as spectacular as the collapse of the B-deal is the failure of any attempts to create "development" for the areas I summed up under the C-deal (the planet's South). In most parts of Africa, average incomes went down during the eighties. Via IMF policies, repression and starvation became more brutal everywhere. A new wave of epidemics like cholera and AIDS was made possible by a complete neglect of medical and social infrastructures. The ultimate collapse of the illusions of development has spurred ever more desperate flows of emigration towards Europe or within the South. The attack on the remaining possibilities of subsistence farming has been engineered with droughts, civil war and deportations. A "New Enclosure" of formerly communal land is under way, driving farmers into cities and converting good lands into plantations for cash crops (exportation). In some regions the refusal of the C-deal has grown into mass movements for the refusal of all deals of "Western Civilization" as a whole. Some of these move-

ments try to use ideological expressions of former stages of the (patriarchal) Machine, and link themselves to "Islamic fundamentalism." It is apparent though, that these movements really care little about Islam, and that they're social and not religious movements. Islam just stands for the concept of "cultural identity" ("*nima?*") that must still be found autonomously by the movement. What we see is just a religiously-styled elite (mostly trained in U.S. universities) trying to transform the fundamental refusal into a source of energy for an "Islamic state" or a phantasmatic "Islamic economy." Iran is already in a final stage of this kind of manipulation, and there are now the first "Islamic fundamentalist revolts" against the Islamic state of the ayatollahs... The ferocity of the U.S. attack against Saddam Hussein can be explained by the fact, that he (undeservedly, of course) had become the champion of "fundamentalist" refusals of all deals, from Indonesia to Morocco and even Trinidad. The Gulf War was the first war waged explicitly against all those who refuse deals... including the A-deal. And now there are others....

(The fact that there *are* deals doesn't mean that they were ever *accepted*. They just represent forms of social armistice in certain phases of struggle against the Machine as such.)

Even the "best" deal, offered to about ten percent (600 million persons) of the Machine's workers, the A-deal of modern consumer society, is no longer what it used to be. Wages in the classic A-deal country, the U.S.A., have gone down to 1957 equivalents, and since 1967 work-weeks per year have risen from 43.9 to 47.1.[1] The Carter, Reagan and Bush years smashed the guarantees of "The American Way of Life" for many sectors of the old working-class, but also for the new middle-classes. Even the yuppies see their expectations betrayed. Phenomena like homelessness, per-

manent unemployment and the "new poverty," as it's called in Europe (what's "new" about it?), have become widespread in A-areas. Even in Switzerland, real wages went down by 5% in 1990, and sociologists found out that 15% of the population of this model A+ country live in poverty. Currently, wages are under heavy attack in Western Europe, mainly through inflation and tax rises (Germany). The bosses tell them to be happy about the end of "communism" (which never existed) and to be ready to pay the price. A strange logic: "we" win and get punished for it. After all, Eastern state-capitalism was one of *their* ideas. The hidden refusal of work (work less and — if you can — spend less) practiced by A-workers has thinned out profits. Complaints about increasing "laziness" can be heard everywhere, even in Switzerland. "Post-materialist" attitudes and behaviors are shared by shadow "silent majorities" in European countries. Workers are evasive, minimalist, have "other interests," retire early, have numerous "psychological" and "health" problems... and many more excuses not to be productive.

This "hidden" strike has eroded the centers of the most advanced capitalist production. Again one of the strategies of the counter-attack is "bankruptcy." Companies just close shop, all the money disappears (including pension funds) and at the same time the state that is expected to guarantee the guarantees declares itself to be in a "budget crisis" and can't pay either. Budget crises, cuts in social spendings, massive lay-offs, wage-cuts, all are the common denominator of such different situations as New York or Zurich. The task of the current recession — to get rid of the "fat cats" and to get the lazy bums with well-paid, part-time jobs jumping — can easily be seen in the "strange" fact that no government is implementing particular anti-cyclical policies. For the first time, there is no deficit spending to get

the economy running again; actually it's the previous — fake — "boom" that has accumulated the biggest deficits ever. So there's no money, no place to go, and old guarantees go down the drain. Nothing is left between you and "pure" capital.

Another big change in the functioning of the A-deal consists in the geographical fragmentation of old homogenous A-deal areas. As I already pointed out in 1983, all three deals are present everywhere. But there used to be blocs or regions, like North America or Western Europe, with a certain predominance of the A-deal. This antediluvian attempt — created by Roosevelt and Stalin in Yalta — to divide the planetary proletariat along geographical demarcation lines, has definitely been undermined by the crisis of the respective deals on both sides. This doesn't mean that there will be fewer or less-pronounced divisions; the end of the divisions would be the end of the machine. But what we see now, more and more, is a kind of leopard-skin pattern of all the deals. New York or Los Angeles resemble almost Third World cities, whereas the center of Rio looks like a cleaner midtown Manhattan. The predominant deal can differ from one neighborhood to the next. A-deal areas become fortresses in a jungle of various C-deals and some B-deal leftovers. The price the Machine had to pay to use the instrument of division called "nation" (solidified in turn by "blocs"), a certain minimal homogeneity of incomes, has obviously risen too high. There is no more national economy, just multinational companies operating all over the planet, wherever profits can be made the easiest. The "New World Order" is just the predator's dream of an unlimited hunting ground. The Gulf War was not a national war, but an operation for the world economy as such. The U.S. Army was just hired to do the job: a new type of planetary Pinkertons. Living in an A-deal country guarantees less and less

— you can be as poor in the U.S. as in Brazil, or as rich in India as in Switzerland.

The crisis and dispersion of the deals is transforming the planetary functioning of the Machine. Instead of different bosses (or blocs) we're now confronted with purely anonymous systems of control and sanctions. Be it called "free market," "law" (with the U.S. "cops of the world" to enforce it), "democracy" or "productivity," power is exerted over us and by "us" via manifold circuits of selection and the self-regulating mechanisms for the allocation of goods. The typical pseudo-boss structures of the nineties will be institutions like the IMF, the World Bank, and certain UN agencies. There is nowhere to go to protest; nobody seems in charge, and those who represent companies or states stand there wringing their hands, blaming market forces or the deficits. Ideologists announce the "end of history," and in a certain sense, they're right): "their" history is ending, and we never needed one.

The new leopard-skin geometry of the deals would seem risky, if the Machine couldn't trust the achieved social atomization and all the automated barriers of qualification, lifestyle, income, race and sex. Living close together in the same cities and mingling on a daily basis, the single workers behave like little spaceships, each on its individual course. Not afraid of organizational short-circuits between these atoms, the Machine can give them a kind of micro-autonomy, and dissipate decision-making all over the pattern. No "ruling" is needed to be in power. But "things" happen....

While there is no use to weep about the old deals, the new menu of deals looks even less appetizing. There is no way back — we're out in the open and a ferocious wind blows. We must choose now if we want to duck and hide in our precarious shelters, or if we use the wind for our purposes — to fly kites or propel our sail boats. To the new

geometry of the Machine we can answer with a *new proletarian geometry*, taking advantage of the new possibilities. With the collapse of socialism not only ideological mystifications have vanished, but new contacts with hundreds of millions of ex-B-workers have become possible. The migrations of C-workers to the North bring numerous fresh encounters and cultural exchanges.

The "end of history" and the fact that we all now face the same bosses (or boss-mechanisms) can bring together workers of the most different backgrounds, and can help to get rid of all the smokescreen illusions about progress and politics. The next time — *this* time — we aren't going to play around with replacing (powerless) governments and tinkering with legitimation and representation; we're going to deal with the *real* thing. Instead of waiting for the next recovery, we can build our own circuits of survival. Why wait for the next job? Why not use our creative potentials for ourselves? Must the East really wait for economic help from the West? Can't farmers and city-dwellers just organize and create self-sufficient country or city communities?

The new migrations greatly facilitate what I called *"dysco"* (solidarity and communication across deal-barriers). On cultural and neighborhood levels, many initiatives have grown in the past years. It is exactly the issue of "land" (housing, social spaces) that has brought together workers of different deals. Land prices and therefore rents have been used all over the planet to restructure territories, to push out unproductive people, and to create the new cocoon-type housing facilities for some A-workers ("gentrification"). But, even for them, rents have become unbearable, and so some common activity is possible. Not surprisingly, the Machine is trying to use all kinds of racist and xenophobic resentments to block such *dyscos*. It has even unearthed the most ridiculous nationalisms — espe-

cially in Eastern Europe — to spoil the newly possible dysco parties. It tries to divert the struggle for land from itself and pit workers against workers.

The distribution of different deals in the form of smaller pockets makes the mechanism of the Machine more flexible, disperses risks of big "accidents," generally increases the "heat" and overall productivity. While it tries to get away from many more "natural" limits (via genetic engineering, cyborgs, virtual realities, fusion and/or solar energy) it is still vulnerable. The ultimate "vision" of a sterile, immune self-reproducing automaton living on decaying human and natural compost — the A-deal Cyborg-Machine reducing the rest of the universe to mere C-deal waste — is not yet real. But the road is open.

There are strategic possibilities for the new proletarian geometricians to stop this automatopia from happening. For example, the Machine is still dependent on petroleum, and vital sources of this basic energy commodity lie exactly in areas where new "fundamentalist" movements are virulent: in the Near and Middle East and the ex-U.S.S.R. Oil and land will be the key words for the constructive forces of refusal ("confusal?") of the Machine. If metropolitan *dyscos* could directly cooperate with the "fundamentalist" C-deal refusers in those areas, the Machine could be slowly paralyzed, some usable wealth could be funnelled to the South via the last petro-dollars, and the land left by the retreating Machine be used for the production of life and communal sovereignty. Sure, the Gulf War was a kind of preventive blow to such thoughts. But there's always another chance....

A common program for all the "confusers" — a hidden anti-economic agenda — can be found in the struggles themselves. The words "proletarian geometry" suggest a program: "proletarian" is derived from Latin *proles,* meaning

"children"; "geometry" contains *gaia* ("earth") and *meter* ("measure," "middle"), but also "mother" (as in "metropolis"). The "children of mother earth" claiming their right to live — what else could it be about? The reason for the unreasonable behavior of workers is (in Machine-language): better reproduction, higher "social costs" — life itself?

In a certain way, our hidden program is therefore "matriarchal," and surely anti-patriarchal. This program is very old; it's actually the *original* program, the history of ancient struggles. New research suggests that the beginning of the present patriarchal Machine is not just lost in mythological mists, but that it started around 3000 B.C., as desperate tribes invaded formerly matriarchal civilizations.[2] Correcting my sloppy remarks about the beginning of centralized domination, it becomes clear that matriarchy created urban cultures of high diversification, and without the tyrannies of the later "asiatic mode of production." The palaces of Chatal Hüyük (7000 B.C.) and Knossos (ending 1400 B.C.) are vast, but not intimidatingly monumental; they show no signs of fortifications, but express urban wealth and joy of life. They prove that non-patriarchal cultures needn't be dull, rural or "happily" stagnant. They were in full technological and social development (on another path of progress) when the patriarchal "accident" happened. Centralized systems of command were also used in matriarchal societies in times of emergency or natural catastrophe, as a kind of exceptional crisis management. As soon as things went back to normal, the center of power dissolved, and the regular procedures of "slow" and "communal" rule resumed. Now it seems that around 3000 B.C. a drought in Innerasia produced a prolonged period of stress and migrations. For many peoples (later known as "Indo-Europeans"), adaptation to the new climate wasn't possible, so they started preying on agricultural societies in Mesopotamia, India and Eurasia. This, in

turn, produced emergency rules in those societies and a process of mutual "patriarchalization" that couldn't be reversed — till now. So what we're dealing with at the moment is nothing else than a temporary anomaly within the normal matriarchal course of human affairs. (When Marx talks about "historic necessity," he's just rationalizing this abnormal state of emergency: 8000 years of matriarchy versus 3000 years of patriarchy.)

Actually, the feeling of being "pushed," "mobilized" (including its military sense), of being on constant "alert," is omnipresent in our everyday lives. Speaking of a matriarchal program, we must make sure not to put matriarchy (or better, matri-anarchy) in symmetry with patriarchy. It doesn't imply another system based on biological distinctions. Matriarchy means the predominance of "motherly" values and structures. All those who help to create and reproduce life (including men) shall have authority, and social structures shall be modelled upon the needs of sustaining life. This type of authority will naturally be much more easily accessible to women or mothers than today's. It won't need apparatuses of enforcement and centralized bodies of control. What I call *bolos* (large communistic households, as they were mentioned by Engels) would be ideally compatible with matriarchy. *Bolos* (if large enough) presuppose the dismantling of external social machines like armies, states or big companies that are the backbones of patriarchal domination. Deprived of this corset, men will just be human beings, free to participate in everyday household life. They will be closer to "their" children and will have the chance to be as "motherly" as the (biological) mothers. Men will become as rational, logical and gifted for mathematics as women are today. Their "natural" strength will be much more appreciated than today, when they just sit hunched over their PCs. Matriarchy doesn't mean a specific lifestyle,

there can be as many matriarchies as you wish, for life always expresses diversity. The roles of men and women can be articulated in infinite ways. (Thus there will be no confusion with traditional or fascist notions of "heroic motherhood" or "female gentleness.") We all can be monsters or saints — that's not the point.

The matriarchal program (Islamic: *umma*?) is alive in the anti-economic movements of "unreasonable" workers around the planet. No need to write an updated *Communist Manifesto*. Against the New Enclosures it advocates common use of land by those who work or live on it — "mother" earth doesn't like fences. There's still enough land on this planet to feed everybody — all we need is direct access of our households to it. But the process of pollution, erosion and destruction of land by the Machine is underway. Movements against the "new market economy" (in Eastern Europe), "development" or the so-called "ecological industrial society" express the conviction that there is immense wealth beyond the economy of scarcity. There are vast potentials of social productivity that are repressed by capitalist economy, because capital would lose control if capital let it flow. To make *scarcity* plausible is therefore one of the tactics of the Machine. Millions of tons of food are destroyed every year, billions of dollars are wasted for the military, goods are wasted through ineffective mass-distribution, hundreds of millions of workers are kept unemployed; the *faux frais* of centralized systems are bigger than their usable output.

The main job of the economy at the moment consists in preventing people from doing something useful. Instead of economies of scale, there are huge *wastes of scale*. There is an adequate material basis for all the utopias we might wish — *bolo'bolo* is just one of the modest appetizers. But of course the movement that is dismantling the Machine cannot just be imagined as a linear accumulation of *bolo* (or sim-

ilar) projects. Single *bolo* projects are sometimes possible in privileged situations, and could play a role as organizational or cultural centers within a more general movement. It would be reactionary to picture them as isolated islands of the future.

One of the immediate practical possibilities of using *bolos* could be movements of appropriation of empty industrial areas. A *rustbelt* of deserted or neglected industrial sites, warehouses, port facilities, railroad areas, etc., stretches now from California to Detroit, from New England to Old England, from Central and Eastern Europe into China and even Japan (between 30° and 60° North). These areas are often close to metropolitan centers, linked by near-planetary railroad tracks, and thanks to a general real estate crisis (e.g., the Docklands in London) realistically available. Why not try to develop a planetary chain of *bolo*-like projects in the *rustbelt* in order to subvert the North from inside and to attack its stranglehold on the South? Projects and contacts within the *rustbelt* could certainly contribute to the above mentioned proletarian geometry. (And we also need a cleaning-up operation before we can start the new-old matriarchal era.)

If we're talking about *bolos* today, we are implicitly trying to understand the mechanisms of structural domination we're subject to right now. This becomes particularly clear when we consider the proposed size of *bolos* (about 500 persons). Some critics have argued that this is too big, and that communities of about 30–50 people would be more practical, and also easier to realize instantly. Instead of aiming at autarky, more cooperation between these mini-*bolos* and neighborhood or citywide organisms should be favored. Now, 500 is certainly not a magical figure, it just describes a size between 300 and 1000 people depending on local conditions and traditions. Whereas com-

munities of 50 people are clearly small, and necessarily dependent on supplementary structures, units of 500 people are rather middle-sized, and can be at least *tactically* self-sufficient. They are not just intentional communities, but middle-sized enterprises. Under present conditions, it is imaginable that they could be founded in the legal form of cooperatives or even stock corporations. Their "product" would then consist in reproducing and guaranteeing the living of their members ("employees"). A lot of politics would take place inside such units; they're not just for providing intimacy. For that purpose *bolos* can be sub-divided into those mini-*bolos* or any other communities (families, *kana*, clans, etc.). The size of a 500-person extended household is vital to ensure a whole series of economies of scale, of divisions of labor, of internalizing otherwise economic functions. There is a *qualitative* leap somewhere between 100 and 300 people. If you go below let's say 300 persons, bartering or supply by exchange contracts become extremely tiresome, because the amount of single shipments will be too small compared to the organizational work needed to get them under way. (Ask any supermarket manager!) Division of labor (washing, cooking, supply, services, child-care, "material feminism," etc.) is vital to make self-management worthwhile, and to insure that community members will benefit from their own gains of cooperation. It will also reduce socially necessary labor. In order to sustain non-hierarchic processes of management, a huge amount of communication work must to be done in committees, so you need a big pool of fresh "managers" to replace worn-out administrators. Small units tend to become "structurally" dictatorial because of communicational stress. Furthermore, units of only 50 people are socially unstable and cannot guarantee the welfare of all their members for a lifetime. We would need state-like struc-

tures or insurance companies to take care of this, and would end up with more anonymous bureaucratic structures and more risks of structural domination than now. The same holds for the direct exchange between city-based *bolos* and their agricultural branches. It would be a big waste of work and energy to link small farms to equally small city-communities. Or we could renounce direct exchange and rely on shops, food-conspiracies and other "anonymous" solutions that, however, would not allow us to create a wholeness of cultural values, social life and food production. (This, I think, is an important matriarchal feature of big *bolos*.) Practical experience must show which size makes a household really communistic; I just want to argue again strongly in favor of the 500-person *bolo*. Of course there's no limit to any type of cooperation between *bolos*. But with big *bolos* the structural risks are smaller, because there's more basic sovereignty.

Other readers have asked questions like: why don't people just get together and live in *bolos*? Why is there no *bolo* movement? Why are people even afraid of living in *bolos*? (I'm not speaking merely of the term *"bolo,"* of course, which is entirely disposable.) Psychological reasons have been brought forward: we're so used to being taken care of by big "mother" state (or economy), that we'd be afraid to be in the open and on our own in *bolos*. (The fear is real: *bolos* are not just resort hotels or neighborhood associations — they mean actual survival, life or death.) We still tend to trust more those politicians and economic leaders who have proven their complete irresponsibility time and time again, still trust them more than ourselves and our own ability to take things in our own hands. I guess that only the development of movements, of self-education by doing, will be able to overcome these "infantile" illusions. When the crisis of the deals gets more visible, it

will become clearer to more and more workers that there is no other mother "out there." Nevertheless, there are now a number of local initiatives to create *"bolos"* of many different types and functions. But as I pointed out above, the end of the Machine is not just *bolo*-building, but the *refusal of work in action*. If some of the practical proposals of *bolo'bolo* should help to strengthen the self-confidence of these movements — namely that there is life beyond economy — they are fulfilling their main purpose.

It appears that seemingly "utopian" proposals like *bolo'bolo* create more confusion than they help to explain things. (The real "utopia" is capitalism.) One of these is the idea that *everybody* should live in *bolos*. It might be sufficient that 60%, 50% or 30% of people live in such basic communities to break the fundamental power of the Machine. Around this core many other "systems" — singles, families, capitalisms, socialisms of different kinds, small states, feudalistic, asiatic or other modes of production, traditional tribes, etc. might find more space to unfold than today. Once the stranglehold of the centers of the Machine — in North America, Europe and Japan — is broken (when history is *really* ended), even earlier stages in the development of the Machine cannot be dangerous any more. Once you get rid of (enforced) progress, uniformity in the levels of productivity becomes obsolete. Different ages and epochs can co-exist. Even truly free-market economies of partners of comparable starting positions could emerge in some odd places, and thereby realize the old liberal utopia for the first time in history. All these oddities are no temptations for a strong core structure built on self-sufficiency. What we have in mind is not the "next stage," but a short-cut across country.

A number of readers of *bolo'bolo* have been confused or irritated by the ironical or macabre tone of some passages.

Some of the more practical suggestions are indeed not to be taken literally (namely about *ibu*, *taku*, *nugo*, *yaka*). They're more illustrations than instructions. Sometimes it was just the dusty genre "utopia" that provoked me to make irreverent jokes. But of course, I'm serious. And you can be as serious — or not — as you wish.

As some necessary adaptations are being made in this apology, I leave this present printing of the text of *bolo'bolo* in its original form (1983) and trust the reader to make further adjustments and to interpret the text according to the author's basic intentions....

I want to seize the opportunity of this "apology" for the English reprinting (I am truly sorry) to thank all disappointed *boloists* and all known and unknown conspirators on all continents for their help in translating, publishing and circulating *bolo'bolo*. In recent years it has appeared in the most unexpected places and social circles. On a modest scale *bolo'bolo* seems to have become a kind of passport for many members of the world-wide anti-economy league. Originally published in 1983 in German, *bolo'bolo* has been translated into French, Italian, Dutch, Portuguese and Russian. Parts of it were published in Japanese and Chinese. Most of this work was volunteered, and "profitable" versions (like the German one, with six printings) have helped to pay for strictly deficit ventures (like the Russian translation). Further translations are encouraged — just get in touch with Autonomedia.

Fresh predictions about the end of the temporary patriarchal anomaly are not in order. But what about a rendezvous in the year 2001, to dance on the ruins of the Planetary Work Machine? Just send your suggestions for date, place and tunes to Autonomedia.

<div style="text-align: right;">P.M.
1st May 1993</div>

If you dream alone, it's just a dream.
If you dream together, it's reality.
(Brazilian folk song)

A Big Hang-over

Life on this planet isn't as agreeable as it could be. Something obviously went wrong on Spaceship Earth, but what? Maybe it was a fundamental mistake when nature (or whatever it was) came up with the idea "man." Why should an animal walk on two feet and start thinking? It seems we haven't got much of a choice about that, though; we've got to cope with this error of nature, with ourselves. Mistakes are made in order to learn from them.

In prehistoric times our deal seems to have been not so bad. During the Old Stone Age (50,000 years ago) we were only few, food (game and plants) was abundant, and survival required only little working time and moderate efforts. To collect roots, nuts, fruits or berries (don't forget mushrooms) and to kill (or easier still, trap) rabbits, kangaroos, fish, birds or deer, we spent about two or three hours a day. In our camps we shared meat and vegetables and enjoyed the rest of the time sleeping, dreaming, bathing, making love or telling stories. Some

of us took to painting cave walls, carving bones or sticks, inventing new traps or songs. We used to roam (along our songlines) about the country in gangs of 25 or so. with as little baggage and property as possible. We preferred the mildest climates, like Africa's, and there was no "civilization" to push us away into deserts, tundras, or mountains. The Old Stone Age must have been a good deal if we can trust the recent anthropological findings. That's the reason we stuck it out for several hundred thousands of years — a long and happy period compared to the 200 years of the present industrial nightmare.

Then somebody must have started playing around with seeds and plants and invented agriculture. It seemed to be a good idea: we didn't have to walk far away to get vegetables any more. But life became more complicated, and restrictive. We had to stay in the same place for at least several months, keep the seeds for the next crop, plan and organize work on the fields. The harvest also had to be defended against our nomadic gatherer/hunter cousins, who kept insisting that everything belonged to everybody. Conflicts between farmers, hunters and cattle breeders arose. We had to explain to others that we had "worked" to accumulate our provisions, and they didn't even have a word for "work." With planning, withholding of food, defense, fences, organization and the necessity of self-discipline we opened the door to specialized social organisms like priesthoods, chiefs, armies. We created fertility religions with rituals in order to keep ourselves convinced of our newly chosen lifestyle. The temptation to return to the free life of gatherers/hunters must always have been a threat. Whether it was patriarchate or matriarchate, we were on the road to statehood (cf. footnote 2).

With the rise of the ancient civilizations in Mesopotamia, India, China and Eyota, the equilibrium between man and natural resources was definitely ruined. The future break-down of our spaceship was programmed. Centralized organisms developed their own dynamics; we became the victims of our own creations. Instead of the two hours per day, we worked ten hours and more on the fields and construction grounds of the pharaohs and the caesars. We died in their wars, were deported as slaves when they needed us for that. Those who tried to return to their former freedom were tortured, mutilated, crucified.

With the start of industrialization, things didn't get better. To crush the peasant rebellions and the growing independence of craftsmen in the towns, they introduced the factory system. Instead of foremen and whips, they used machines. They dictated to us our work rhythms, punished us automatically with accidents, kept us under control in huge halls. Once again "progress" meant working more and more under still more murderous conditions. From 1440 hours per year in 1300 work rose to 3650 hours in 1850 — in 1987 it was at 2152 and is rising.[2] The whole society and the whole planet was turned into one big Work Machine. And this Work Machine was simultaneously a War Machine for anybody outside or inside who dared oppose it. War became industrial, just like work; indeed, peace and work have never been compatible. You can't accept to be destroyed by work and prevent the machine you create with it from killing others. You can't refuse your own freedom and not threaten the freedom of others. War became as absolute as work.

The early Work Machine produced strong illusions of a "better future." After all, if the present was so miserable, the future must be better. Even the working class organizations became convinced that industrialization would lay the basis for a society of more freedom, more free time, more pleasures. Utopians, socialists and communists believed in industry. Marx thought that with its help man would be able to hunt, make poetry, enjoy life again. (Why the big detour?) Lenin and Stalin, Castro and Mao, and all the others demanded More Sacrifice to build the new society. But even socialism only turned out to be another trick of the Work Machine, extending its power to areas where private capital couldn't or wouldn't go. The Work Machine doesn't care if it is managed by transnational corporations or state bureaucracies, it's goal is the same everywhere: steal our time to be able to steal the next generation's time.

The industrial Work and War Machine has definitely ruined our spaceship earth and its predictable future: the furniture (jungles, woods, lakes, seas) is torn to shreds; our playmates (whales, turtles, tigers, eagles) have been exterminated or are endangered; the air (smog, acid rain, ozone, industrial exhaust gases) stinks and has lost all sense of balance; the pantries (fossil fuels, coal, metals, water) are being emptied; complete self-destruction (nuclear holocaust) is being prepared for. We aren't even able to distribute enough food to all the passengers of this wretched vessel. We've been made so nervous and irritable that we're ready for the worst kind of nationalist, racial or religious wars. For many of us, nuclear holocaust isn't any longer a threat, but rather a welcome deliverance from fear, boredom, oppression and drudgery.

Three thousand years of civilization and 200 years of accelerated industrial progress have left us with a terrible hang-over. "Economy" has become a goal in itself, and we're about to be swallowed by it. This hotel terrorizes its guests. Even when we're guests and hosts at the same time.

The Planetary Work Machine

The name of the monster that we have let grow and that keeps our planet in its grips is: The Planetary Work Machine. If we want to transform our spaceship into an agreeable place again, we've got to dismantle this Machine, repair the damage it has done, and come to some basic agreements on a new start. So, our first question must be: how does the Planetary Work Machine manage to control us? How is it organized? What are its mechanisms and how can they be destroyed?

It is a Planetary Machine: it eats in Africa, digests in Asia, and shits in Europe. It is planned and regulated by international companies, the banking system, the circuit of fuels, raw materials and other goods. There are a lot of illusions about nations, states, blocs, First, Second, Third or Fourth Worlds, but these are only minor subdivisions, parts of the same machinery. Of course there are distinct wheels and transmissions that exert pressure, tensions, frictions on each other. The Machine is built on its inner contradictions: workers/capital; private capital/state capital (capitalism/ socialism); development/underdevelopment; misery/waste; war/peace; women/men; etc. The Machine is not a homogenous structure; it uses its internal contradictions to expand its control and to refine its instruments. Unlike fascist or theocratic systems or like in

Orwell's *1984*, the Work Machine permits a "sane" level of resistance, unrest, provocation and rebellion. It digests unions, radical parties, protest movements, demonstrations and democratic changes of regimes. If democracy doesn't function, it uses a dictatorship. If its legitimation is in crisis, it has prisons, torture and camps in reserve. All these modalities are not essential to understand the functioning of the Machine.

The principle that governs all activities of the Machine is the *economy*. But what is economy? Impersonal indirect exchange of crystallized life-time. You spend your time to produce some part, which is used by somebody else you don't know to assemble some device that is in turn bought by somebody else you don't know for goals also unknown to you. The circuit of these scraps of life is regulated according to the working time that has been invested in its raw materials, its production, and in you. The means of measurement is money. Those who produce and exchange have no control over their common product, and so it can happen that rebellious workers are shot with the exact guns they have helped to produce. Every piece of merchandise is a weapon against us, every supermarket an arsenal, every factory a battleground. This is the mechanism of the Work Machine: split a society into isolated individuals, blackmail them separately with wages or violence, use their working time according to its plan. Economy means: expansion of control by the Machine over its parts, making the parts more and more dependent on the Machine itself. We are all parts of the Planetary Work Machine we *are* the machine. We represent it against each other. Whether we're developed or not, waged or not, wether we work alone or

as employees we serve its purpose. Where there is no industry, we "produce" low-cost workers to export to industrial zones. Africa has produced slaves for the Americas, Turkey produces workers for Germany, Pakistan for Kuwait, Ghana for Nigeria, Morocco for France, Mexico for the U.S. Untouched areas can be used as sceneries for the international tourist business: Indians on reservations, Polynesians, Balinese, aborigines. Those who try to get out of the Machine fulfill the function of picturesque "outsiders" (bums, hippies, yogis). So long as the Machine exists, we're inside it. It has disintegrated or mutilated almost all traditional societies or driven them into demoralizing defensive situations. If you try to retreat to a "deserted" valley in order to live quietly on a bit of subsistence farming, you can be sure you'll be found by a tax collector, somebody working for the local draft board, or by the police. With its tentacles, the Machine can reach virtually every place on this planet within just a few hours. Not even in the remotest parts of the Gobi Desert can you be assured of an unobserved shit.

The Three Essential Elements of the Machine

Examining the Machine more closely, we can distinguish three essential functions, three components of the international work force, and three "deals" the Machine offers to different fractions of us. These three functions can be characterized like this:

A) INFORMATION: planning, design, guidance, management, science, communication, politics, the production of ideas, ideologies religions, art, etc.; the collective brain and nerve system of the Machine.

B) PRODUCTION: industrial and agricultural production of goods, execution of plans, fragmented work, circulation of energy.

C) REPRODUCTION: production and maintenance of A, B, and C workers, making children, education, housework, services, entertainment, justice, sex, recreation, medical care, etc.

All these three functions are essential for the functioning of the Machine. If one of them fails, it will sooner of later be paralyzed. Around these three functions, the Machine has created three types of workers to perform them. They're divided by their wage levels, privileges, education, social status, etc.

A) TECHNICAL/INTELLECTUAL WORKERS in advanced (Western) industrial countries: highly qualified, mostly white, male, and well paid. A good example would be computer engineers.

B) AGRO/INDUSTRIAL WORKERS and employees in not yet "de-industrialized" areas, in "threshold" countries, socialist countries: modestly or miserably paid, male or female, with wide ranging qualifications. For example, automobile assembly workers, electronics assembly workers (female).

C) Fluctuant Workers, oscillating between small agricultural and seasonal jobs, service workers, housewives, the unemployed, criminals, petty hustlers, those without regular income. Mostly women and non-whites in metropolitan slums or in the Third World, these people frequently live at the edge of starvation.

All these types of workers are present in all parts of the world, just in different proportions. Nevertheless, it's possible to distinguish three zones with a typically high proportion of the respective type of workers:

A Workers in advanced industrial (Western) countries, in the U.S., Europe, Japan.

B Workers in socialist countries or the newly industrializing countries, in the USSR, Eastern Europe, Taiwan, South Korea, etc.

C Workers in the Third World, agricultural or "underdeveloped' areas in Africa, Asia, and South America, and in urban slums everywhere.

The "Three Worlds" are present everywhere. In New York City there are neighborhoods that can be considered as part of the Third World. In Brasil there are major industrial zones. In socialist countries there are strong A type elements. But there is still a pronounced difference between the United States and Bolivia, between Sweden and Laos, and so on.

The power of the Machine, its control mechanism, is based on playing off the different types of workers

against each other. High wages and privileges are not granted because the Machine has a special predilection for a certain kind of particular worker. Social stratification is used for the maintenance of the whole system. The three types of workers learn to be afraid of each other. They're kept divided by prejudices, racism, jealousy, political ideologies, economic interests. The A and B workers are afraid of losing their higher standard of living, their cars, their houses, their jobs. At the same time, they continually complain about stress and anxiety, and envy the comparatively idle C workers. C workers in turn dream of fancy consumer goods, stable jobs, and what they see as easy life. All these divisions are exploited in various ways by the Machine.

The Machine doesn't even need anymore a special ruling class to maintain its power. Private capitalists, the bourgeoisie, aristocrats, chiefs of all kinds are mere leftovers, without any decisive influence on the material execution of power. The machine can do without capitalists and owners, as the examples of the socialist states, state enterprises in the West and stock holding corporations demonstrate. These relatively rare fat cats are not the real problem. The truly oppressive organs of the Machine are all controlled by just other workers: cops, soldiers, bureaucrats. We're always confronted with the convenient metamorphoses of our own kind.

The Planetary Work Machine is a machinery consisting of people put up against each other; we all guarantee its functioning. So an early question is: why do we put up with it? Why do we accept to live a kind of life we obviously don't like? What are the advantages that make us endure our discontent?

Three Deals in Crisis

The contradictions that make the Machine move are also internal contradictions for every worker, they're our contradictions. Of course, the Machine "knows" that we don't like this life, and that it is not sufficient just to oppress our wishes. If it were just based on repression, productivity would be low and the cost of supervision too high. That's why slavery was abolished. In reality, one half of us accepts the Machine's deal and the other half is in revolt against it.

The Machine has indeed got something to offer. We give it a part of our lifetimes, but not all. In turn, it gives us a certain amount of goods, but not exactly as much as we want and not exactly what we want. Every type of worker has its own deal, and every worker makes his or her own little extra deal, depending on particular job and specific situation. As everyone thinks he or she is better off than somebody else (there is always somebody worse off), everybody sticks to his or her own deal, distrusting all changes. So the inner inertia of the Machine protects it against reform and revolution alike.

Only if a deal has become too unequal can dissatisfaction and readiness to change the situation arise. The present crisis, which is visible mainly on the economic level, is caused by the fact that *all* deals the Machine has to offer have become unacceptable. A, B, and C workers alike have protested recently, each in their own ways, against their respective deals. Not only the poor, but also the rich, are dissatisfied. The Machine is finally losing its perspective. The mechanism of internal division and

mutual repulsion is collapsing. Repulsion is turning back on the Machine itself.

The A Deal: Disappointed with Consumer Society

What makes up the A Deal? Steaks, good stereos, surfing, Chivas Regal, Tai Chi, Acapulco, Nouvelle Cuisine, coke, skiing, exclusive disco, Alfa Romeos. Is this the Machine's best offer?

But what about those mornings while commuting? That sudden rush of angst, disgust, despair? We try not to face that strange void, but in unoccupied moments between job and consuming, while we are waiting, we realize that time just isn't ours. The Machine is duly afraid of those moments. So are we. So we're always kept under tension, kept busy, kept looking forward toward something. Hope itself keeps us in line. In the morning we think of the week-end, we sustain everyday life by planning the next vacation from it. In this way we're immunized against reality, numbed against the loss of our energies. We're always somewhere else.

The A Deal hasn't become foul (or better: distinctly fouler) because the quantity or variety of consumer goods is lacking. However mass production has levelled out their quality, and the fascination of their "newness" has definitely disappeared. Meat has become somehow tasteless, vegetables have grown watery, milk has been transformed into just processed white liquid. TV is deadly dull, driving is no longer pleasurable, neighborhoods are either loud and crowded and unsafe or de-

serted and unsafe. At the same time, the really good things, like nature, traditions, social relations, cultural identities, intact urban environments, are destroyed. In spite of the huge flood of goods, the quality of life plummets. Our life has been standardized, rationalized, anonymized. They track down and steal from us every unoccupied second, every unused square foot. They offer us — some of us — quick vacations in exotic places thousands of miles away, but in our everyday lives our maneuvering room gets smaller and smaller.

Also for A workers, work still remains work: loss of energies, stress, nervous tension, deadlines, hysterical competition, hierarchical control and abuse. No consumer goods can fill up the holes made by work. Passivity, isolation, inertia, emptiness: these are not cured by new electronics in the apartment, frenzied travel, meditation/relaxation workshops, creativity courses, zipless fucks, pyramid power or drugs. The A Deal is poison: its revenge comes in depression, cancer, allergies, addiction, mental troubles and suicide. Under the perfect make-up, behind the façade of the "affluent society," there's only new forms of human misery.

A lot of thus "privileged" A workers flee to the countryside, take refuge in sects, try to cheat the Machine with magic, oriental religions or other illusions of secret power. Desperately they try to get some structure, meaning, and sense back into their lives. But sooner or later the Machine catches its refugees and transforms exactly their forms of rebellion into a new impetus of its own development. "Sense" soon means business sense.

Of course, the A Deal doesn't only mean misery. The A workers have indeed got some undeniable privileges.

As a group they've got access to all the goods, all the information, all the plans and creative possibilities of the Machine. The A workers have the chance to use this wealth for themselves, and even against the goals of the Machine, but if they act only as A workers, their rebellion is always partial and defensive. The Machine learns quickly. Sectorial resistance always means defeat.

The B Deal: Frustrated by Socialism

The B Deal is the classic industry/worker/state deal. The "positive" aspects of this deal (from the workers' point of view) are guaranteed jobs, guaranteed incomes, social security. We can call this deal "socialism" because it occurs in its purest form in socialist or communist countries. But the B Deal also exists in many different versions in private capitalist countries (Sweden, Great Britain, France, even in the U.S.A.).

At the center of the B Deal there's The State. Compared to the anonymous dictatorship of the market and money, a centralized state does seem able to give us more security. It seems to represent society (i.e., us) and the general interest, and through its mediation many B workers consider themselves their own bosses. Since the State has assumed vital functions everywhere (pensions, health services, social security, police), it seems to be indispensable, and any attack against it easily looks like suicide. But the State is really just another face of the Machine, not its abolition. Like the market, it constitutes its anonymity by means of massification and isolation, but in this case it's The Party (or parties), the bureaucracy, the administrative apparatus, that fulfill this task.

(In this context, we're not talking about democracy or dictatorship. A socialist state could in fact be perfectly democratic. There's no intrinsic reason why socialism even in the USSR shouldn't become democratic one day. The form of the state itself, though, always means dictatorship; it's just a question of degree how democratically its legitimation is organized.)

We face the State ("our" state) as powerless individuals, provided with "guarantees" which are just pieces of paper and do not establish any form of direct social control. We're alone, and our dependence upon the state bureaucracy is just an expression of our real weakness. In periods of crisis, some good friends are much more important than our social security cards or our savings accounts. The State means fake security.

In the socialist countries, where the B Deal exists in its purer form, there remains the same system of constraint by wage and by work as is found in the West. We all still work for the same economic goals. Something like a "socialist" lifestyle, for which accepting some sacrifices might make sense, has emerged nowhere; nothing like that is even planned. Socialist countries still use the same motivation systems as in the West: modern industrial society, "Western" consumer society, cars, TV sets, individual apartments, the nuclear family, summer cottages, discos, Coca Cola, designer jeans, etc. As the level of productivity of these countries remains relatively low, these goals can be only partially reached. The B Deal is particularly frustrating, since it pretends to realize consumer ideals it is far from able to fulfill.

But of course socialism doesn't mean only frustration. It does have real advantages. Its productivity is low be-

cause the workers there exert a relatively high level of control over working rhythms, working conditions and quality standards. As there's no risk of unemployment and firing is difficult, the B workers can take it relatively easy. Factories are overstaffed, sabotage is an everyday event, absenteeism for shopping, alcoholism, black market entrepreneurism and other illegal businesses are wide-spread. B-Deal workers are also "officially" encouraged to take it easier, for there are not enough consumer goods to go around, hence little incentive to work harder. Thus the circle of under-productivity is closed. The misery of this system is visible in a profound demoralization, in a mixture of alcoholism, boredom, family feuds, ass-kissing careerism.

As the socialist countries become ever more integrated into the world market, underproductivity leads to catastrophic consequences; B Deal countries can only sell their products by dumping them at below market prices, so B workers are actually exploited in low-wage industrial colonies. The few useful goods produced flow right to the West; their continuing absence in their own countries is an additional reason for B-worker anger and frustration.

The recent events in Poland (1981) have shown that more and more B workers are refusing the socialist deal. Understandably, there are great illusions about consumer society and the possibility of reaching it through state economic means. (Lech Walesa, for example, was fascinated by the Japanese model.) A lot of people in socialist countries (for example, East Germany) are beginning to realize that high productivity consumer society is just another type of misery, and certainly no

way out. Both the Western and socialist illusions are about to collapse. The real choice isn't between capitalism and socialism, for both alternatives are offered by the one and same Machine. Rather a new "solidarity" will be needed, not to build a better industrial society and to realize the affluent universal socialist consumer family, but to tie direct relations of material exchange between farmers and city dwellers, to get free from big industry and state. The B workers alone will not be able to accomplish this.

The C Deal: The Development of Misery

Before the industrial Work Machine colonized the actual Third World, there was poverty. "Poverty": that means that people possessed few material goods and had no money, though they still got enough to eat, and everything they needed for their way of life was available. "Wealth" was originally "software." Wealth was not determined by things and quantities but by forms: myths, festivals, fairy tales, manners, eroticism, language, music, dance, theater, etc. (It's also evident that the way "material" pleasures are perceived is determined by cultural traditions and conceptions.) The Work Machine has destroyed most of the wealth aspects of this "poverty," and has left *misery* in its place.

When the money economy hits poverty, the result is the development of misery, maybe even just "development." Development can be colonialist, independent (managed by indigenous elites or bureaucracies), social-

ist (state capitalist), private capitalist, or some mix of these. The result, however, is always the same: loss of local food resources, (cash crops replace subsistence agriculture), blackmailing on the world market (terms of trade, productivity gaps, "loans"), pauperization, repression, civil wars among rival ruling cliques, military dictatorships, intervention by the super-powers, dependence, torture, massacres, deportation, disappearances, famine.

The central element of the C Deal is direct violence. The Work Machine deploys its mechanisms of control openly and without any inhibitions. The ruling cliques have the task of building up functioning, centralized states, and for that reason all tribal, traditionalist, autonomist, "backward" and "reactionary" tendencies and movements must be crushed. The often absurdly defined territories they've inherited from the colonial powers have to be transformed into "modern" national states. The Planetary Work Machine cannot do without well-defined, normalized and stable parts. That is the sense of the actual "adjustments" in the Third World, and for that goal millions have to die or are deported.

National independence has not brought the end of misery and exploitation. It has only adjusted the old colonial system to the new requirements of the Work Machine. Colonialism wasn't efficient enough. The Machine needed national masks, promises of progress and modernization to get the temporary consent of the C workers. In spite of the subjective good will of many elites (e.g. N'Krumah, Nyerere, etc.), development has only prepared the ground for a new attack by the Work Machine, has demoralized and disillusioned the C masses.

For most C workers, the *family* is at the center of their deal, eventually the clan, the village or the tribe. C workers cannot rely on the money economy, since waged work is scarce and miserably paid. The state isn't able to grant any social guarantees. So the family is the only form for even minimal security. Yet, the family itself has an ambiguous character: it provides safety amidst ups and downs, but at the same time it is also another instrument of repression and dependence. That's true for the C workers all over the world, even in the industrialized countries (expecially so for women). The Work Machine destroys family traditions, and exploits them at the same time. The family yields a lot of unpaid work (especially by women); the family produces cheap labor for unstable jobs. The family is the place of work for the C worker.

The C workers in developing countries find themselves in an enervating situation: they're called upon to give up the old (family, village), but the new can't give them a sufficient means of survival. So they come to the cities and end up in slums. They hear of new consumer goods, but they can't earn enough to buy them. Simultaneously their villages and their agricultural bases decay, and become manipulated, corrupted and abused by the ruling caste. At least the C Deal has the advantage of relative lack of restraint in everyday life, and few new responsibilities: they aren't tied to jobs or to the State, they're not blackmailed with long term guarantees (pensions, etc.), they can take advantage of any opportunities right on the spot. In this regard, they've still got some of the left-over freedoms of the old gatherers/hunters. Changes can easily be put into action, and the possibility of "going home again" to the vil-

lage (or what's left of it) is a real option that A and B workers just don't have. This basic freedom is at the same time a burden, for each day means an entirely new challenge, life is never safe, food has become uncertain, and risks are always high. Criminal bands, political cliques, quick profiteers exploit this fact and easily recruit hustlers, pushers, and mercenaries.

In spite of the ubiquitous commercial advertizing and development propaganda, more and more C workers are realizing that the proposed consumer society will always remain a *fata morgana*, at best a reward only to the upper ten percent for their services to the Machine. Capitalist and socialist models have failed, and the village is no longer a practical alternative. As long as there is only this choice between different styles of misery, there's no way out for the C workers. On the other side, they've got the best chances for a new way of life based on self-sufficiency, for industrial and state structures are very weak, and many problems (like energy, shelter, even food) are obviously much easier to solve locally than in metropolitan areas. But if the C workers as a class try to go back to their villages before the Planetary Work Machine has been dismantled everywhere else, too, they'll be doubly cheated. The solution is global, or it is not at all.

The End of Realpolitik

Misery in the Third World, frustration in the socialist countries, deception in the West: the main dynamics of the Machine are actually reciprocal discontent and the logic of the lesser evil. What can we do? Reformist politicians propose to tinker with the Ma-

chine, trying to make it more humane and agreeable by using its own mechanisms. Political realism tells us to proceed by little steps. Thusly, the present micro-electronic revolution is supposed to give us the means for reforms. Misery will be transformed into mobilization, frustration into activism, and disappointment will be the basis of a change of consciousness. Some of the reformist proposals sound quite good: the twenty-hour work-week, equal distribution of work on everyone, the guaranteed minimum income or negative income tax, elimination of unemployment, mutual self-help, decentralized self-administration in enterprises and neighborhoods, the creation of an "autonomous" sector with low-productivity small enterprise, investments in middle and soft technologies (also for the Third World), the reduction of private traffic, the conservation of non-renewable energy, no nukes, investment in solar, public transportation systems, less animal protein in our diets, more self-sufficiency for the Third World, the recycling of raw materials, global disarmament, etc. These proposals are reasonable, even realizable, and certainly not extravagances. They form more or less the official or secret program of the alternativist-socialist-green-pacifist movements in Western Europe, the United States, and other countries. Should many of these reforms be realized, the Work Machine would look much more bearable. But even these "radical" reform programs only imply a new adjustment to the Machine, not its demise As long as the Machine itself (the hard, "heteronomous" sector) exists, self-management and "autonomy" can only serve as a kind or recreational area for the repair of exhausted workers. And who can prevent that you won't get just as ruined in a 20-hour work

week as you've been in 40? As long as this monster isn't pushed into space, it'll continue to devour us.

What's more, the political system is designed to block such proposals, or convert reforms into a new impulse for the further development of the Machine. The best illustration for this fact are the electoral politics of reformist parties. As soon as the Left gets the power (take a look at France, Greece, Spain, Bolivia, etc.), it gets entangled in the jungle of "realities" and economic necessities and has no choice but to enforce precisely those austerity programs it attacked when the Right was in charge. Instead of Giscard it's Mitterrand who sends the police against striking workers. Instead of Reagan it's Mondale who campaigns against budget deficits. Socialists have always been good police. The "recovery of the economy" (i.e., the Work Machine) is the basis for every national politics; reforms always have to prove that they encourage investment, create jobs, increase productivity, etc. The more the "new movements" enter Realpolitik (like the Greens in Germany), the more they enter the logic of "healthy economy," or else they disappear. Besides destroying illusions, increasing resignation, developing general apathy, reformist politics doesn't achieve anything. The Work Machine is planetary. All its parts are interconnected. Any national reformist policy just makes for harder international competition, playing off the workers of one country against those of another perfecting the control over all.

It is exactly this experience with Realpoliticians and reformers that have led more and more voters to support neoconservative politicians like Reagan, Thatcher, or Kohl. The most cynical representatives of the logic of

economy are preferred to well-meaning leftist tinkerers. The self-confidence factor of the Machine has grown shaky. Nobody dares anymore to believe fully in its future, but everybody still clings to it. The fear of experiments has outgrown the belief in demagogical promises. Why reform a system that's doomed, anyway? Why not try to enjoy the few last positive aspects of the old personal or national deals with the Machine? Why not put in charge positive, confident, conservative politicians? The ones who don't bother to promise to solve problems like unemployment, hunger, pollution, nuclear arms races. They're not elected to solve problems of this sort, but to represent continuity. For the "recovery", only a little bit of calm, stability, positive rhetoric is needed: the security to cash in on profits made by present investments. Under these conditions, any recovery will be much more terrible than the "crisis" is. Nobody really has to believe in Reagan or Kohl, just keep smiling along with them, forgetting about worries or doubts. The Work Machine, in a situation like the present, supports doubts very badly, and with the neoconservative regimes you're at least left alone until the end of the next "recovery" or catastrophe. Aside from agitation, bad moods and remorse, the Left has nothing additional to offer. Realpolitik is hardly realistic anymore, since reality is now at a turning point.

All or Nothing at All

The Planetary Work Machine is omnipresent; it can't be stopped by politicians. So will the Machine be our destiny, until we die of heart disease

or cancer at 65 or 71? Will this have been Our Life? Have we imagined it like this? Is ironical resignation the only way out, hiding from ourselves our deceptions for the few rushing years we've got left? Maybe everythings's really okay, and we're just being over-dramatic?

Let's not fool ourselves. Even if we mobilize all our spirit of sacrifice, all of our courage, we can achieve not a thing. The Machine is perfectly equipped against political kamikazes, as the fate of the Red Army Faction, the Red Brigades, the Monteneros and others has shown. It can coexist with armed resistance, even transform that energy into a motor for its own perfection. Our attitude isn't a moral problem, not for us, much less for the Machine.

Whether we kill ourselves, whether we sell out in our own special deals, find an opening or a refuge, win the lottery or throw Molotov cocktails, join the Sparts or the Bhagwan, scratch our ears or run amok: we're finished. This reality offers us nothing. Opportunism does not pay off. Careers are bad risks; they cause psychoses, marriages. Bailing out means self-exploitation in ghettoes, panhandling on filthy street corners, crushing bugs between rocks out in the garden of the commune. Cleverness has grown fatiguing. Stupidity is annoying.

It would be logical to ask ourselves some questions like these: "How would I really like to live?" "In what kind of society (or nonsociety) would I feel most comfortable?" "What do I really want to do with myself?" "Regardless of their practicality, what are my true wishes and desires?" And let's try to picture all this not in a remote future (reformists always like to talk about "the next generation"), but in our own lifetimes, while we're still in pretty good shape, let's say within the next five years....

Dreams, ideal visions, utopias, yearnings alternatives: aren't these just new illusions to seduce us once again into participating in a scheme for "progress?" Don't we know them from the neolithic, from the 17th-century, from the science-fiction and fantasy literature of today? Do we succumb again to the charm of History? Isn't The Future the primary thought of the Machine? Is the only choice that between the Machine's own dream and the refusal of any activity?

There's a kind of desire that, whenever it arises, is censored scientifically, morally, politically. The ruling reality tries to stamp it out. This desire is the dream of a *second reality*.

Reformists tell us that it's short-sighted and egoistic to follow just one's own wishes. We must fight for the future of our children. We must renounce pleasure (that car, vacation, a little more heat) and work hard, so that the kids will have a better life. This is a very curious logic. Isn't it exactly the renunciation and sacrifice of our parents' generation, their hard work in the '50s and '60s, that's brought about the mess we're in today? *We are already* those children, the ones for whom so much work and suffering has gone on. For us, our parents bore (or were lost to) two world wars, countless "lesser" ones, innumerable major and minor crises and crashes. Our parents built, for us, nuclear bombs. They were hardly egoistic; they did what they were told. They built on sacrifice and self-renunciation, and all of this has just demanded more sacrifice, more renunciation. Our parents, in their time, passed on their own egoism, and they have trouble respecting ours.

Other political moralists could object that we're hardly allowed to dream of utopias while millions die of

starvation, others are tortured in camps, disappear, are deported or massacred. Minimal human rights alone are hard to come by. While the spoiled children of consumer society compile their lists of wishes, others don't even know how to write, or have no time to even think of wishes. Yet, look around a little: know anybody dead of heroin, any brothers or sisters in asylums, a suicide or two in the family? Whose misery is more serious? Can it be measured? Even if there were no misery, would our desires be less real because others were worse off, or because we could imagine ourselves worse off? Precisely when we act only to prevent the worst, or because "others" are worse off, we make this misery possible, allow it to happen. In just this way we're always forced to react on the initiatives of the Machine. There's always an outrageous scandal, an incredible impertinence, a provocation that cannot be left unanswered. And so our seventy years go by and the years of the "others," too. The Machine has no trouble keeping us busy with that. It's a good way to prevent us from becoming aware of these immoral desires. If we started to act for ourselves, there would definitely be trouble. As long as we only (re-)act on the basis of "moral differences," we'll be powerless as dented wheels, simply exploding molecules in the engine of development. And as we're already weak, the Machine just gets more power to exploit the still weaker.

Moralism is one weapon of the Machine, realism another. The Machine has formed our present reality, trained us to see in the Machine's way. Since Descartes and Newton, it has digitized our thoughts, just like reality. It's laid its yes/no patterns over the world, over our spirits. We believe in this reality, maybe because we're so

used to it. Yet as long as we accept the Machine's reality, we're its victims. The Machine uses its digital culture to pulverize our dreams, presentiments and ideas. Dreams and utopias are sterilized in novels, films, commercialized music. But this reality is in crisis; every day, there are more cracks, and the yes/no alternative isn't much less than an apocalyptic threat. The Machine's ultimate reality reads self-destruction.

Our reality, the second reality of old and new dreams, cannot be caught in the yes/no net. It refuses apocalypse and the status quo all at once. Apocalypse or Evangel, armageddon or utopia, all or nothing: these are the "realist" possibilities. In this reality, we choose one or the other, lightheartedly. But medium attitudes like "hope," "confidence," or "patience" are just ridiculous — pure self-deceit. There is no hope. We have to choose *now*.

Nothingness has become a realistic possibility, more absolute than the old nihilists dared dream of. In this respect, the Machine's accomplishments must certainly be acknowledged. Finally, we've gotten to Nothingness! We do not *have to* survive! Nothingness has become a realistic "alternative" with its own philosophy (Cioran, Schopenhauer, Buddhism, Glücksmann), its fashion (black, uncomfortable), music, housing style, painting, etc. Apocalyptics, nihilistics, pessimists, and misanthropists have all got good arguments for their attitude. After all, if you transform into values "life," "nature," or "mankind," there are only totalitarian risks, biocracy or ecofascism. You sacrifice freedom to survival; new ideologies of renunciation arise and contaminate all dreams and desires. The pessimists are the real free ones, happy and generous. The world will never again be support-

able without the possibility of its self-destruction, just as the life of the individual is a burden without the possibility of suicide. Nothingness is here to stay.

On the other side, "all" is also quite appealing. It's of course much less probable than nothingness, badly defined, poorly thought out. It's ridiculous, megalomaniacal, self-conceited. Maybe it's only around to make Nothingness more attractive.

bolo'bolo

bolo'bolo is part of (my) second reality. It's strictly subjective, since the reality of dreams can never be objective. Is *bolo'bolo* all or nothing? It's both, and neither. It's a trip into second reality, like Yapfaz, Kwendolm, Takmas, and Ul-So. Down there there's a lot of room for many dreams. *bolo'bolo* is one of those unrealistic, amoral, egoistic maneuvers of diversion from the struggle against the worst.

bolo'bolo is also a modest proposal for the new arrangements on the spaceship after the Machine's disappearance. Though it started as a mere collection of wishes, a lot of considerations about their realization have accumulated around it. *bolo'bolo* can be realized worldwide within five years, if we start now. It guarantees a soft landing in the second reality. Nobody will starve, freeze or die earlier than today in the transition period. There's very little risk.

Of course, general conceptions of a postindustrial civilization are not lacking these days. Be it the eruption of the Age of Aquarius, the change of paradigms, ecotopia, new networks, rhizomes, decentralized structures, soft society, the new poverty, small circuitry, third waves, or prosumer societies, the ecological or alterna-

tivist literature grows rapidly. Allegedly soft conspiracies are going on, and the new society is already being born in communes, sects, citizens' initiatives, alternative enterprises, block associations. In all these publications and experiments there are a lot of good and useful ideas, ready to be stolen and incorporated into *bolo'bolo*. But many of these futures (or "futuribles," as the French say) are not very appetizing: they stink of renunciation, moralism, new labors, toilsome rethinking, modesty and self-limitation. Of course there are limits, but why should they be limits of pleasure and adventure? Why are most alternativists only talking about new responsibilities and almost never about new possibilities?

One of the slogans of the alternativists is: Think globally, act locally. Why not think *and* act globally *and* locally? There are a lot of new concepts and ideas, but what's lacking is a practical global (and local) proposal, a kind of common language. There has to be some agreement on basic elements, so that we don't stumble into the Machine's next trap. In this regard, modesty and (academic) prudence is a virtue that risks disarming us. Why be modest in the face of impending catastrophe?

bolo'bolo might not be the best and most detailed or certainly a definitive proposal for a new arrangement of our spaceship. But it's not so bad, and acceptable to a lot of people. I'm for trying it as a first attempt and seeing what happens later....

Substruction

In case we'd like to try *bolo'bolo*, the next question will be: How can we make it happen? Isn't it just another Realpolitical proposal? In fact, *bolo'bolo* cannot be re-

alized with politics; there's another road, a range of other roads, to be followed.

If we deal with the Machine, the first problem is obviously a negative one: How can we paralyze and eliminate the Machine's control (i.e., the Machine itself) in such a way that *bolo'bolo* can unfold without being destroyed at the start? We can call this aspect of our strategy "deconstruction," or *subversion*. The Planetary Work-Machine has to be dismantled carefully, because we don't want to perish together with it. Let's not forget that we're parts of the Machine, that it *is us*. We want to destroy the Machine, not ourselves. We only want to destroy our function for the Machine. Subversion means to change the relationships among us (the three types of workers) and towards the Machine (which faces all workers as a total system). It is subversion, not attack, since we're still all inside the Machine and have to block it from there. The Machine will never confront us as an external enemy. There will never be a front line, no headquarters, no ranks, no uniforms.

Subversion alone, though, will always be a failure, though with its help we might paralyze a certain sector of the Machine, destroy one of its capabilities. Finally, the Machine is always able to reconquer and occupy again. Every space initially obtained by subversion has instead to be filled by us with something "new," something "constructive." We cannot hope to eliminate first the Machine and then — in an "empty" zone — establish *bolo'bolo;* we'd always arrive too late. Provisional elements of *bolo'bolo*, seedlings of its structures, must occupy all free interstices, abandoned areas, conquered bases, and prefigure the new relationships. *Construction* has to be

combined with subversion into one process: *substruction* (or "conversion," if you prefer). Construction should never be a pretext to renounce on subversion. Subversion alone creates only straw fires, historical dates and "heroes," but it doesn't leave concrete results. Construction and subversion are both forms of tacit or open collaboration with the Machine.

Dysco

Dealing first with subversion, it's clear that every type of work, any one who functions for the Machine in any part of the world, has his or her own specific potential for subversion. There are different ways of damaging the Machine, and not every one has the same possibilities. A planetary menu for subversion could be described a little like this:

A) DYSINFORMATION: sabotage (of hardware or programs), theft of machine-time (for games or any private purposes), defective design or planning, indiscretions (e.g., Ellsberg and the Watergate scandal), desertions (scientists, officials), refusal of selection (by teachers), mismanagement, treason, ideological deviation, false information to superiors, etc. And effects can be immediate or quite long-term seconds or years.

B) DYSPRODUCTION: opting out, low quality manufacturing, sabotage, strikes, sick leaves, shop-floor assemblies, demonstrations in the factories, use of mobility, occupations (e.g., the recent struggles of Polish workers). These effects are usually medium-term weeks or months.

C) DYSRUPTION: riots, street blockades, violent acts, flight, divorce, domestic rows, looting, guerrilla warfare, squatting, arson (e.g., Sao Paulo, Miami, Soweto, El Salvador). Effects here are short-term hours or days.

Of course, all these acts also have long-term effects; we're here only talking about their direct impact as forms of activity. Any of these types of subversion can damage the Machine, can even paralyze it temporarily. But each of them can be neutralized by the two other forms — their impact is different according to time and space. Dysinformation remains inefficient if it's not used in the production or physical circulation of goods or services. Otherwise, it becomes a purely intellectual game and destroys only itself. Strikes can always be crushed if nobody, by dysruptive actions, prevents the police from intervening. Dysruption ends swiftly so long as the Machine gets its supply from the production-sector. The Machine knows that there will always be subversion against it, and that the deal between it and the different types of workers will always have to be bargained for and fought out again. It only tries to stagger the attacks of the three sectors so that they can't support and multiply each other, becoming a kind of counter-machine. Workers who have just won a strike (dysproduction) are angry about unemployed demonstrators who prevent them, via a street blockade, from getting back to the factory on time. A firm goes bankrupt, and the workers complain about poor managers and engineers. But what if it was a substructive engineer who willfully produced a bad design, or a manager who wanted to sabotage the

firm? The workers still lose their jobs, take part in unemployment demonstrations, finally engage in riots… until the policeworkers come and do their jobs. The Machine transforms the single attacks of different sectors into idle motion, for nothing is more instructive than defeats, nothing more dangerous than long periods of calm (in this latter case, the Machine loses the ability to tell what's going on inside the organisms of its body). The Machine can't exist without a certain level of sickness and dysfunction. Partial struggles become the best means of control — a kind of fever thermometer — providing it with imagination and dynamism. If necessary, the Machine can even provoke its own struggles, just to test its instruments of control.

Dysinformation, dysproduction, and dysruption would have to be joined on a mass level in order to produce a critical situation for the Machine. Such a deadly conjuncture could only come into being by the overcoming of the separation of the three functions and worker types. There must emerge a kind of communication that's not adequate to the design of the Machine: dyscommunication. The name of the final game against the Machine is thus ABC-*dysco*.

Where can such ABC-*dysco* knots develop? Hardly where workers meet in their Machine functions — that is, at the work place, in the supermarket, in the household. A factory is precisely organized division, and things like unions only mirror this division, not overcome it. On the job, different interests are particularly accentuated; wages, positions, hierarchies, privileges, titles, all of these build up walls. In the factories and offices, workers are isolated from each other, the noise (physical, semantic,

cultural) levels are high, tasks are too absorbing. ABC-dysco is not likely to happen best in the economic core of the Machine.

But there are domains of life — for the Machine, mostly marginalized domains — that are more propitious for dysco. The Machine hasn't digitized and rationalized everything: often, in fact, not religion, mystic experiences, language, native place, nature, sexuality, desire, all kinds of spleens, crazy fixations, just plain fancy. Life as a whole still manages to slip away from the Machine's basic pattern. Of course, the Machine has long been aware of its insufficiency in these fields, and has tried to functionalize them economically. Religion can become sect-business, nature can be exploited by tourism and sport, the love of one's home can degenerate into an ideological pretext for the weapons industries, sexuality can be commodified, etc. Basically, there's no need or desire that can't be merchandised, but as merchandise it of course gets reduced and mutilated, and the true needs and desires move on to something else. Certain needs are particularly inappropriate for mass production: above all, authentic, personal experience. Commodification succeeds only partially, and more and more people become aware of "the rest." The success of the environmental movements, of the peace movement, of ethnic or regionalist movements, of certain forms of new "religiousness" (progressive or pacifist churches), of the homosexual subcultures, is probably due to this insufficiency. Wherever identities that lie beyond the logic of the economy have been newly discovered or created, there can be found ABC knots. As "war objectors," intellectuals, shopkeepers, women and men have met. Homosexuals gather without primary regard

for job identity. Navajos, Basques, or Armenians struggle together; a kind of "new nationalism" or regionalism overcomes job and education barriers. The Black Madonna of Czestochowa contributed in uniting Polish farmers, intellectuals and workers alike. It's no accident that in recent times it's almost exclusively these types of alliances that have given movements certain strengths. Their substructure power is based on the multiplication of ABC encounters that have been possible in their frameworks. One of the first reactions of the Machine has always been to play off against each other the elements of these encounters, reestablishing the old mechanism of mutual repulsion. The above-mentioned movements have only produced superficial and short-lived ABC-*dysco*. In most cases, the different types just touched each other on a few occasions and then slipped back into their everyday division, as before. They created more mythologies than realities. In order to exist longer and to exert substantial influence, they should also be able to fulfill everyday tasks outside of the Machine, should also comprise the constructive side of substruction. They should attempt the organization of mutual help, of moneyless exchange, of services, of concrete cultural functions in neighborhoods. In this context, they should become anticipations of *bolos*, of barter-agreements, of independent food supply, etc. Ideologies (or religions) are not strong enough to overcome barriers like income, education, position. The ABC-types have to *compromise themselves* — in everyday life. Certain levels of self-sufficiency, of independence from state and economy, must be reached to stabilize such *dysco*-knots. You can't work forty hours per week and still have the time and energy for neighborhood initiatives.

ABC-knots can't just be cultural decorations, they must be able to replace at least a small fraction of money income, in order to get some free time. How these ABC-*dysco* knots will look, practically, can only be discovered on the practical level. Maybe they will be neighborhood centers, food conspiracies, farmer/craftsmen exchanges, street communities, commune bases, clubs, service exchanges, energy co-ops, communal baths, car pools, etc. All kinds of meeting points — bringing together all three types of workers on the basis of common interests — are possible ABC-*dyscos*.

The totality of such ABC knots disintegrates the Machine, producing new subversive conjunctures, keeping in motion all kinds of invisible movements. Diversity, invisibility, flexibility, the absence of names, flags or labels, the refusal of pride or honor, the avoidance of political behavior and the temptations of "representation" can protect such knots from the eyes and hands of the Machine. Information, experiences, and practical instruments can be shared in this way. ABC-*dysco* knots can be laboratories for new, puzzling, and surprising forms of action, can use all three functions and the respective dysfunctions of the Machine. Even the brain of the Machine has no access to this wealth of information, since it must keep divided the very thinking about itself (the principle of divided responsibility and competence). ABC-*dysco* knots are not a party, not even a kind of movement, coalition or umbrella organization. They're just themselves, the cumulation of their single effects. They might meet in punctual mass movement, testing their strength and the reaction of the Machine, and then disappear again into everyday life. They combine their forces where they

meet each other in practical tasks. They're not an anti-Machine movement, but they are the content and material basis for the destruction of the Machine.

Due to their conscious non-organizedness, ABC knots are always able to create *surprises*. Surprise is vital, as we're at a fundamental disadvantage when faced with the Machine, one that cannot be easily overcome: we can always be blackmailed by the constant threats of death or suicide pronounced by the Planetary Machine. It can't be denied that guerrilla warfare as a means of subversion can be necessary in certain circumstances (where the Machine is already engaged in killing). The more ABC knots, networks and tissues there are, the more the Machine's death instinct is awakened. But it's already part of our defeat if we have to face the Machine with heroism and readiness for sacrifice. Somehow, we have to accept the Machine's blackmailing. Whenever the Machine starts killing, we have to retreat. We shouldn't frighten it; it has to die in a moment when it least suspects. This sounds defeatist, but it's one of the lessons we have to learn from Chile, from Poland, from Grenada. When the struggle can be put on the level involving the police or the military, we're about to lose. Or, if we do win, it's exactly our own police or military that will have won, not us at all; we'll end up with one of those well-known "revolutionary" military dictatorships. When the Machine takes to raw killing, *we* have obviously made a mistake. We must never forget that *we* are also those who shoot. We're never facing the enemy, we *are* the enemy. This fact has nothing to do with the ideologies of non-violence; the most violent ideologies often refrain from killing. Damage to the Machine and violence are not nec-

essarily linked. Nor, however, does it serve us to put flowers into the buttonholes of uniforms, or go out of our way to be nice to the police. They can't be swindled by phony symbolism, arguments or ideologies *they are like us*. Still, maybe the cop has some good neighbors, maybe the general's gay, maybe the guy on the front lines has heard from his sister about some ABC-*dysco* knot. When there get to be enough dyscos, there are also enough security leaks and risks for the Machine. We will of course have to be careful, practical, discrete.

When the Machine kills, there aren't yet enough ABC-*dyscos*. Too many parts of its organism are still in good health, and it's trying to save itself with preventive surgery. The Machine won't die of frontal attack, but it can very well die of ABC-cancer, learning about it only too late for an operation. These are just the rules of the game; those who don't respect them better get right out (let them be the heroes).

Substruction as a (general) strategy is a form of practical meditation. It can be represented by the following *yantra,* combining substruction (the movement aspect) with *bolo* (the future basic community):

Trico

The Work Machine has a planetary character, so a successful *bolo'bolo* strategy must also be planetary from the outset. Purely local, regional or even national dysco knots will never be sufficient to paralyze the Work Machine as a whole. West, East and South must start simultaneously to subvert their respective functions inside the Machine and create new, constructive anticipations. What's true for the three types of workers on a micro-level is also true for the three parts of the world on a macro-level. There must be planetary *dysco* knots. There must be *tricommunication* between *dysco* knots: *trico*, the planetary *trico* trick. *Trico* is *dysco* between ABC knots in each of the three major parts of the world: Western industrial countries, socialist countries, underdeveloped countries. A *trico* knot is the encounter of three local ABC knots on an international level.

Anticipations of *bolos* must be established outside of governments, away from existing international organizations or development-aid agencies. The contacts must function directly between neighborhoods, between everyday initiatives of all kinds. There might be a *trico* between St. Mark's Place in New York's East Village, North East 7 in Gdansk, Poland, and Mutum Biyu in Nigeria; or perhaps Zurich-Aussersihl, Novosibirsk Block A 23, and Fuma, Fiji Islands. Such *trico* knots could first originate on the basis of accidental personal acquaintances (tourist trips, etc.). Then they could be multiplied by the activity of already existing *tricos*. The practical use of the *trico* knot (and there must be one)

can be very trivial in the beginning: the exchange of necessary goods (medicine, records, spices, clothes, equipment), done moneylessly, or at least as cheaply as possible. It's obvious that the conditions of exchange of goods are far from equal among the three parts of the world; the Third World partner in a *trico* will need a lot of basic products to make up for the exploitation by the world market. Third World communities will also need a lot of material for the construction of a basic infrastructure (fountains, telephones, generators). Nevertheless, this doesn't mean that the *trico* is just a type of development aid. The partners will be creating a common project, the contact will be person to person, the aid will be adapted to real needs and based on personal relationships. Even under these conditions, exchange won't necessarily be one-sided. A workers in a *dysco* knot will give a lot of material goods (as they have plenty), but they'll get much more in cultural and spiritual "goods" in return; they'll learn a lot about lifestyles in traditional settings, about the natural environment, about mythologies, other forms of human relations. As we've said before, even the most miserable C Deals offer some advantages; instead of frightening our A-selves with the disadvantages of other deals, we'll exchange those elements that are still valuable and strong.

The *trico* knots permit the participating ABC *dysco* knots to unmask the mutual illusions of their deals, and assist in stopping the division game of the Work Machine. Western *dyscos* will learn about socialist everyday life, ridding themselves of both red-baiting anti-communism and ridiculous socialist propaganda. The Eastern partners will find themselves giving up

their impossible fantasies about the Golden West, and at the same time will be better able to immunize themselves against the official indoctrination in their own countries. Third World dyscos will protect themselves from "development" ideologies, socialist demagogy and blackmail by misery. All this won't be foisted off as and "educational" process, but will be a natural consequence of tricommunication. A Western *dysco* knot might help the Eastern partner get a Japanese stereo (needs are needs, even those created by the Machine's advertizing strategies). In the process of trico-expansion, of closer exchange and of growing *bolo'bolo* structures, authentic wishes will become predominant. Dances and fairy tales from Dahomey will be more interesting than TV game shows, gritty Russian folk songs will sound more attractive than Pepsi jingles, etc.

Planetary substruction from the beginning is a precondition for the succes of the strategy that leads to *bolo'bolo*. If *bolo'bolo* remains just the spleen of a single country or region, it's lost; it will become just another impulse for "development." On the basis of tricommunication, those planetary relationships come into being that will disintegrate nation-states and the political blocs. Like the *dysco* knots, the *trico* knots will form a substructive network that'll paralyze the Work Machine. Out of *tricos* will come barter agreements (*fenos*), general hospitality (*sila*), new culturally defined regions (*sumi*), and a planetary meeting point (*asa'dala*). The *trico* network will also have to block the war machines of single countries from the inside, thus proving to be the real peace movement — simply because they're not primarily interested in "peace," but because they've got a common, positive project.

Provisional Schedule

If everything works out well, *bolo'bolo* can be realized by the end of 1987. We're responsible ourselves for delays. The following schedule may be useful to judge our progress:

1984 — *bolo'bolo* pamphlets, stickers, posters and signs are spread worldwide in the major languages. ABC-*dysco* knots develop in many neighborhoods, cities and regions, contacts of self-sufficiency are created. There are the first *trico* knots. Some *dyscos* get transformed into pioneer and experimental *bolos*. In some neighborhoods people study the usefulness of buildings and spaces for *bolos*, exchange centers, and the like, and make other provisional plans. More and more streets are blocked to automobile traffic. The political Machine suffers everywhere from heavy legitimation crises, and has trouble maintaining control. State organs fulfill their repressive functions slovenly and inattentively.

1985 — There are *dysco* and *trico* networks, fulfilling more and more practical, everyday tasks: mutual help for food, planetary help, the creation of exchange relationships between farmers and country *dyscos*. In certain, smaller, regions the Machine loses its influence and independent areas develop unperceived. State apparatuses suffer from substruction attacks.

1986 — Larger regions become independent, among others, in Oregon, Tadzhikistan, Saxony, Wales, Switzerland, Australia, Ghana, Brazil. In these areas, agriculture is modeled on self-reliance, structures are

built up, planetary exchange is strengthened. Toward the end of the year there exists a planetary leopard-skin of regions, autonomous countries (*yudo*), single *bolos*, leftovers of the Machine, amputated States, military bases. General disorders break out. The Machine tries to crush the *bolos* militarily, but the troops mutiny. The two superpowers give up their bloc-game and unite in the USSAR (United Stable States and Republics. The USSAR builds up a new, purified, industrial base in inner-Asia, Monomat.

1987 — The international systems of transportation and communication collapse. Two hundred autonomous regions hold their first planetary convention (*asa'dala*) in Beirut. They agree to reestablish the communication system on a new basis. The USSAR is limited to Monomat, and the rest of the world slips way from its control. In the fall, there's self-sufficiency everywhere, and planetary systems of mutual emergency aid. Hunger and states are abolished. Towards the end of the year the Monomat workers desert and flee into the *bolo* zone. The USSAR disappears without formal dissolution, and without having burned its red and white flag with the blue star.

1988–2345 — *bolo'bolo*

2346 — *bolo'bolo* loses its strength as "the whites" (a kind of cultural epidemic) spreads and replaces all other types of *bolos*. *bolo'bolo* lapses into an age of chaos and contemplation.

2764 — Beginning of Yuvuo. All records on pre-history (up to 2763) have been lost. Tawhuac puts a new floppy disk into the drive.

IBU

In fact, there's really only the *ibu*, and nothing else. But the *ibu* is unreliable, paradoxical, perverse. There's only one single *ibu*, but nevertheless it behaves as if there were four billion or so. The *ibu* also knows that it invented the world and reality by itself, yet it still firmly believes that these hallucinations are real. The *ibu* could have dreamed an agreeable, unproblematic reality, but it insisted on imagining a miserable, brutish and contradictory world.[3]

It has dreamed a reality in which it is constantly tormented by conflict, catastrophe, crisis. It's torn between ecstasy and boredom, between enthusiasm and deception, between tranquility and agitation. It has a body that needs 2000 calories a day, that gets tired, cold, gets ill; it expels this body every 70 years or so — a lot of unnecessary complication.

The *ibu's* external world is a continuing nightmare, too. Enervating dangers keep it caught between fear and heroism. All the while, it could end this ghastly theatre by killing itself and disappearing forever. Since there's only one single *ibu* and the universe that it has dreamed up for itself, it has no care about surviving dependents, mourning friends, unpaid bills, etc. Its death would be absolutely without consequences. Nature, humanity, his-

tory, space, logic, everything disappears together with it. The *ibu's* toils are completely voluntary, and yet it affirms that it's only a powerless element of a greater reality. Why all of this self-deceit?

Apparently, the *ibu* is in love with its own masochistic nightmare of torture. It has even protected this nightmare scientifically against nothingness. It defines dreams as unreal, so its nightmare becomes the dream of the unreality of dreaming. The *ibu* has locked itself into the reality trap.

Natural laws, logic, mathematics, scientific facts and social responsibilities form the walls of this reality trap. As the *ibu* insists upon dreaming its own powerlessness, power comes from exterior instances to whom the *ibu* owes its obedience: God, Life, the State, Morality, Progress, Welfare, the Future, Productivity. On the basis of these pretensions, it invents the "sense of life," which it can never reach, of course. It feels constantly guilty, and is kept in an unhappy tension in which it forgets itself and its power over the world.

In order to prevent itself from recognizing itself and finding out the dream-character of its reality, the ibu has invented "others." It imagines that these artificial beings are like itself. As in an absurdist drama, it entertains "relations" with them, loving or hating them, even asking them for advice or philosophical explanations. So it flees from its own consciousness, delegating to others in order to be rid of it. It concretizes the "other" *ibus* by organizing them into institutions: couples, families, clubs, tribes, nations, mankind. It invents "society" fot itself and subjects to its rules. The nightmare is perfect.

Only if there are accidental cracks in its dream world does the *ibu* deal with itself. But, instead of terminating

this perverse existence, the *ibu* pities itself, stays dead by remaining alive. This repressed suicide is displaced outwards, to "reality," and returns from there back to the *ibu* in the form of collective apocalypse (nuclear holocaust, ecological catastrophe). Too weak to kill itself, the *ibu* looks to reality to do that for it.

The *ibu* likes to be tortured, so it imagines wonderful utopias, paradises, harmonious worlds that of course can never be realized. These only serve to fix up the nightmare, giving the *ibu* still-born hopes and instigating it to all kinds of political and economic enterprises, activities, revolutions, and sacrifices. The *ibu* always takes the bait of illusions or desires. It doesn't understand reason. It forgets that all worlds, all realities, all dreams and its own existence are infinitely boring and tiresome and that the only solution consists in retiring immediately into comfortable nothingness.

BOLO

The *ibu* is still around, refusing nothingness, hoping for a new, better nightmare. It's still lonely, but it believes that it can overcome its loneliness by some agreements with the "other" four billion ibus. Are they out there? You can never be sure….

So, together with 300 to 500 *ibus*, the *ibu* joins a *bolo*. The *bolo* is its basic agreement with other *ibus*, a direct, personal

context for living, producing, dying.[4] The *bolo* replaces the old "agreement" called money. In and around the *bolo* the *ibus* can get their daily 2000 calories, a living space, medical care, the basics of survival, and indeed much more.

The *ibu* is born in a *bolo*, it passes its childhood there, is taken care of when it's ill, learns certain things, tinkers around, is hugged and stroked when sad, takes care of other *ibus*, hangs out, disappears. No *ibu* can be expelled from a *bolo*. But it's always free to leave it and return. The *bolo* is the *ibu's* home on our spaceship.

The *ibu* isn't obliged to join a *bolo*. It can stay truly alone, form smaller groups, conclude special agreements with *bolos*. If a substantial part of all *ibus* unite in *bolos*, money economies die and can never return. The near-complete self-sufficiency of the *bolo* guarantees its independence. The *bolos* are the core of a new, personal, direct way of social exchange. Without *bolos*, the money economy must return, and the *ibu* will be alone again with its job, with its money, dependent on pensions, the State, the police. The self-sufficiency of the *bolo* is based on two elements: on the buildings and equipment for housing and crafts (*sibi*), and on a piece of land for the production of most of its food (*kodu*). The agricultural basis can also consist of pastures, mountains, fishing and hunting grounds, palm tree groves, algae cultures, gathering areas, etc., according to geographical conditions. The *bolo* is largely self-sufficient so far as the daily supply of basic food is concerned. It can repair and maintain its buildings and tools by itself. In order to guarantee hospitality (*sila*), it must be able to feed an additional 30–50 guests or travelers out of its own resources.[5]

Self-sufficiency isn't necessarily isolation or self-restraint. The *bolos* can conclude agreements of exchange

with other *bolos* and get a larger variety of foods or services (see *feno*). This cooperation is bi- or multilateral, not planned by a centralized organization; it's entirely voluntary. The *bolo* itself can choose its degree of autarky or interdependence, according to its cultural identity (*nima*).

Size and number of inhabitants of *bolos* can be roughly identical in all parts of the world. Its basic functions and obligations (*sila*) are the same everywhere. But its territorial, architectural, organizational, cultural and other forms or values (if there are any) can be manifold. No *bolo* looks like any other, just as no *ibu* is identical with any other. Every *ibu* and *bolo* has its own identity. And *bolo'bolo* is not a system, but a patchwork of micro-systems.

bolos don't have to be built in empty spaces. They're much more a utilization of existing structures. In larger cities, a *bolo* can consist of one or two blocks, of a smaller neighborhood, of a complex of adjacent buildings. You just have to build connecting arcades, overpasses, using first floors as communal spaces, making openings in certain walls, etc. So, a typical older neighborhood could be transformed into a *bolo* like this:

sibi'bolo kodu

10 km

Larger and higher housing projects can be used as vertical *bolos*. In the countryside, a *bolo* corresponds to a

small town, to a group of farmhouses, to a valley. A *bolo* needn't be architecturally unified. In the South Pacific, a *bolo* is a coral island, or even a group of smaller atolls. In the desert, the *bolo* might not even have a precise location; rather, it's the route of the nomads who belong to it (maybe all members of the *bolo* meet only once or twice a year). On rivers or lakes, *bolos* can be formed with boats. There can be *bolos* in former factory buildings, palaces, caves, battleships, monasteries, under the ends of the Brooklyn Bridge, in museums, zoos, at Knotts Berry Farm or Fort Benning, in the Iowa Statehouse, shopping malls, the University of Michigan football stadium, Folsom Prison. The *bolos* will build their nests everywhere, the only general features are their size and functions. Some possible shapes of *bolos:*

bolo'bolo

bolo'bolo

SILA

From the point of view of the *ibu*, the *bolo's* function is to guarantee its survival, to make its life enjoyable, to give it a home or hospitality when it's traveling. The agreement between the whole of the *bolos* (*bolo'bolo*) and a single *ibu* is called *sila*. As the *ibu* hasn't any money (nor a job!), nor any obligation to live in a *bolo*, all *bolos* have to guarantee hospitality to arriving single *ibus*. Evey *bolo* is a virtual hotel, any *ibu* a virtual non-paying guest. (We're only guests on this planet, anyway.)

Money is a social agreement whose observance is enforced by the police, justice, prisons, psychiatric hospitals. It is not natural. As soon as these institutions collapse or malfunction, money loses its "value" — nobody can catch the "thief," and everybody who doesn't steal is a fool.[6]

As the money agreement functions badly, is in fact about to ruin the planet and its inhabitants, there is some interest in replacing it with a new arrangement, *sila*, the rules of hospitality.[7]

sila contains the following agreements:

taku Every *ibu* gets a container from its *bolo* that measures 50 x 50 x 100 cm, and over whose contents it can dispose at its will.

yalu	Any *ibu* can get from any *bolo* at least one daily ration of 2000 calories of local food.
gano	Every *ibu* can get housing for at least one day in any *bolo*.
bete	Every *ibu* is entitled to appropriate medical care in any *bolo*.
fasi	Every *ibu* can travel anywhere at any moment — there are no borders.
nima	Every *ibu* can choose, practice and propagandize for its own way of life, clothing style, language, sexual preferences, religion, philosophy, ideology, opinions, etc., wherever it wants and as it likes.
yaka	Every *ibu* can challenge any other *ibu* or a larger community to a duel, according to those rules.
nugo	Every *ibu* gets a capsule with a deadly poison, and can commit suicide whenever it wants. It can also demand aid for this purpose.

The real basis of the *sila* are the *bolos*, because single *ibus* wouldn't be able to guarantee these agreements on a permanent basis. *sila* is a minimal guarantee of survival offered by the *bolos* to their members and to a certain proportion of guests. A *bolo* can refuse *sila* if there are more than 10% guests. A *bolo* has to produce 10% more food,

housing, medicine, etc., than it needs for its stable members. Larger communities (like the *tega* or *vudo*) handle more resources, should certain *bolos* have surpluses, or if more than 10% guests show up.

Why should the *bolos* respect hospitality rules? Why should they work for others, for strangers? *bolos* consist of *ibus* and these *ibus* are potential guests or travelers, too; everybody can take advantage of hospitality. The risk of abuse or exploitation of the resident *ibus* by the traveling *ibus* is very low. First, a nomadic life-style has its own disadvantages, since you can then never participate in the richer inner life of a *bolo*. A traveling *ibu* has to adapt to a new cuisine and culture, cannot take part in longterm enterprises, and can always be put on a minimum ration. On the other side, travelers can also benefit the visited community; traveling can even be considered a form of "work." Travelers are necessary for the circulation of news, fashions, ideas, know-how, stories, products, etc. Guests are interested in fulfilling these "functions" because they can expect better-than-minimal hospitality. Hospitality and travelling are a level of social exchange.

A certain pressure to respect hospitality is exerted on the *bolos* by *munu*, honor or reputation. The experiences had by travellers to a *bolo* are very important, since *ibus* can travel very far and talk about them anywhere. Reputation is crucial, because possible mutual agreements between *bolos* are influenced by it. Nobody would like to deal with unreliable, unfriendly *bolos*. As there is no more anonymous mediation by the circulation of money, personal impressions and reputation are essential again. In this regard, *bolos* are like aristocratic lineages, and their image is formed by honor.

TAKU

The first and most remarkable component of *sila* is the *taku*, a container made of solid sheet metal or wood, that looks like this:

According to the customs of its *bolo*, every *ibu* gets a *taku*. Whatever fits into the *taku* is the *ibu's* exclusive property — the rest of the planet is used and held together. Only the *ibu* has access to the things contained in its *taku* — nobody else. It can put into it what it wants. It can carry the *taku* with itself, and no *ibu* has any right under any circumstances whatsoever to inspect its contents or to ask for information about it (not even in cases of murder or theft). The *taku* is absolutely unimpeachable, holy, taboo, sacrosanct, private, exclusive, personal. But only the *taku*. The *ibu* can store in it dirty clothes or machine guns, drugs or

old love letters, snakes or stuffed mice, diamonds or peanuts, stereo tapes or stamp collections. We can only guess. As long as it doesn't stink or make noise (i.e., exert influences beyond itself) anything can be in it.

As the *ibu* might be very obstinate (*ibus* being notoriously peculiar and perverse), it needs some property. Maybe the idea of property is just a temporary degeneration caused by civilization, but who knows? The *taku* is the pure, absolute and refined form of property, but also its limitation. (All the *ibus* together could still imagine to "own" the whole planet, if that helps make them happy.) The *taku* could be important for the *ibu*, helping it remember, for example, that it isn't an *abu, ubu, gagu* or something else equally unclear, unstable, or indefinable. In fact, the single *ibu* has many other opportunities for minimal security about its identity: mirrors, friends, psychiatrists, clothes, tapes, diaries, scars, birthmarks, photos, souvenirs, letters, prayers, dogs, computers, "wanted" circulars, etc. The *ibu* doesn't need objects in order not to lose its identity in a general ecstasy. Yet the loss of intimate things could be very disagreeable, and therefore should be protected against. Maybe the *ibu* needs secret intercourse with obscure caskets, collections, fetishes, books, amulets, jewels, trophies and relics so it can believe itself something special. It needs something to show to other *ibus* when it wants to prove its trust. Only what is secret and taboo can really be shown. Everything else is evident, dull, without charm or glamour.

Like unlimited property, the *taku* brings some risks, too, though these are now more concrete and direct. The *taku* can contain weapons, poisons, magical objects, dynamite, maybe unknown drugs. But the *taku* can never exert the unconscious, uncontrolled social domination that money and capital do today. There is a (limited) danger;

KANA

The *kana* might be the most frequent and practical subdivision of a *bolo*, since the *bolo* is probably too large for immediate living together.[8] A *kana* consists of 15–30 *ibus*, and a *bolo* contains about 20 *kanas*. A *kana* occupies a larger house in a city, or a couple of houses combined to a single household. It corresponds to a hamlet, a hunting group, a kinship group, a community. The kana is organized around the inner domestic (or hut-, tent-, boat-) life, yet it is completely defined by the lifestyle and cultural identity of its *bolo*. It cannot be independent in its supply of food or goods, for it's too small and therefore too unstable (as the experiences of the 1960s alternative communities shows).

According to the *bolo*-lifestyle, there can be more arrangements besides the *kana:* couples, triangles, nuclear families, parenthoods, households, teams, etc. A *bolo* can also consist of 500 single *ibus* who live together, as in a hotel or a monastery, each on its own, cooperating only on a minimal level to guarantee survival and hospitality. The degree of collectivity or individualism is only limited by these basic necessities. Any *ibu* can find the *bolo* or *kana* it likes, or found new ones.

NIMA

Bolos can't just be neighborhoods or practical arrangements. That is only their technical, external aspect. The real motivation for *ibus* to live together is a common cultural background, the *nima*. Every *ibu* has its own conviction and vision of life as it should be, but certain *nimas* can only be realized if like-minded *ibus* can be found. In a *bolo*, they can live, transform and complete their common *nima*. On the other side, those *ibus* whose *nimas* exclude social forms (hermits, bums, misanthropists, yogis, fools, individual anarchists, magicians, martyrs, sages or witches) can stay alone and live in the interstices of the ubiquitous, but far from compulsory, *bolos*.

The *nima* contains habits, lifestyle, philosophy, values, interests, clothing styles, cuisine, manners, sexual behavior, education, religion, architecture, crafts, arts, colors, rituals, music, dance, mythology, body-painting: everything that belongs to a cultural identity or tradition. The *nima* defines life, as the *ibu* imagines it, in its practical everyday form.

The sources of *nimas* are as manifold as they are. They can be ethnic traditions (living or re-discovered ones), philosophical currents, sects, historical experiences, common struggles or catastrophes, mixed forms or newly invented ones. A *nima* can be general or quite specific (as in the case of sects or ethnic traditions). It can be extremely original or only a variant of another *nima*. It can be very open to innovation or closed and conservative. *nimas* can

appear like fashions, or spread like epidemics, and die out. They can be gentle or brutal, passive-contemplative or active-extraverted.[9] The *nimas* are the real wealth of the *bolos* ("wealth" = manifold spiritual and material possibilities).

As any type of *nima* can appear, it is also possible that brutal, patriarchal, repressive, dull, fanatical terror cliques could establish themselves in certain *bolos*. There are no humanist, liberal or democratic laws or rules about the content of *nimas* and there is no State to enforce them. Nobody can prevent a *bolo* from committing mass suicide, dying of drug experiments, driving itself into madness or being unhappy under a violent regime. *bolos* with a bandit *nima* could terrorize whole regions or continents, as the Huns or Vikings did. Freedom and adventure, generalized terrorism, the law of the club, raids, tribal wars, vendettas, plundering — everything goes.

On the other side, the logic of *bolo'bolo* puts a limit on the practicability and the expansion of this kind of behavior and these traditions. Looting and banditry has its own economics. Furthermore, it's absurd to transpose motivations of the present system of money and property into *bolo'bolo*. A bandit-*bolo* must be relatively strong and well-organized, and it needs a structure of internal discipline and repression. For the ruling clique inside such a *bolo*, this would have to mean permanent vigilance and a high amount of repression-work. Their *ibus* could leave the *bolo* at any moment, other *ibus* could show up and the surrounding *bolos* would be able to observe the strange evolutions in such a *bolo* from the beginning. They could send guests, restrict their exchange, ruin the *munu* of the bandit-*bolo*, help the oppressed of the *bolo* against the ruling clique. Supplying food and other goods, getting weapons and equipment would pose severe problems. The *ibus* of the bandit-*bolo* would have to work in the first place to get a

basis for their raids: hence the possibility of rebellion against the chiefs. Without a State apparatus on a relatively large scale, repression would require a lot of work and would not be easily profitable for the oppressors. Raids and exploitation would not be very profitable, either, because there is no means to preserve the stolen goods in an easily transportable form (no money). Nobody would enter into an exchange with such a *bolo*. So it would have to steal goods in their natural form, which means a lot of transportation work and the necessity of repetitious raids. As there are few streets, few cars, scarce means of individual transportation, a bandit-*bolo* could only raid its neighbors, and would quickly exhaust their resources. Add the resistance of other *bolos*, the possible intervention of militias of larger communities (*tega, vudo, sumi*: see *yaka*) and banditry becomes a very unprofitable, marginal behavior.

Historically, conquest, plundering and oppression between nations have always been effects of internal repression and of lack or impossibility of communication. Both causes cannot exist in *bolo'bolo: bolos* are too small for effective repression, and at the same time the means of communication are well-developed (telephone networks, computer networks, ease of travel, etc). In single *bolos* domination doesn't pay off, and independence is only possible with an agricultural base. Predator *bolos* are still possible, but only as a kind of *l'art pour l'art*, and for short periods of time. Anyway, why should we start all that again, as we have now at our disposal the experiences of history? And who should be the world-controllers if we're not able to understand these lessons?

In a larger city, we could find the following *bolos*: Alco-*bolo*, Sym-*bolo*, Sado-*bolo*, Maso-*bolo*, Vegi-*bolo*, Les-*bolo*, Franko-*bolo*, Italo-*bolo*, Play-*bolo*, No-*bolo*, Retro-*bolo*, Thai-bolo, Sun-*bolo*, Blue-*bolo*, Paleo-*bolo*, Dia-*bolo*, Punk-*bolo*, Proto-*bolo*, Krishna-*bolo*, Taro-*bolo*, Jesu-*bolo*, Tao-*bolo*, Para-

bolo, Pussy-*bolo*, Marl-*bolo*, Necro-*bolo*, Basket-*bolo*, Coca-*bolo*, Incapa-*bolo*, HighTech-*bolo*, Indio-*bolo*, Alp-*bolo*, Mono-*bolo*, Metro-*bolo*, Acro-*bolo*, Soho-*bolo*, Herb-*bolo*, Macho-*bolo*, Hebro-*bolo*, Ara-*bolo*, Freak-*bolo*, Straight-*bolo*, Pyramido-*bolo*, Marx-*bolo*, Sol-*bolo*, Tara-*bolo*, Uto-*bolo*, Sparta-*bolo*, Bala-*bolo*, Gam-*bolo*, Tri-*bolo*, Logo-*bolo*, Mago-*bolo*, Anarcho-*bolo*, Eco-*bolo*, Dada-*bolo*, Digito-*bolo*, Subur-*bolo*, Bom-*bolo*, Hyper-*bolo*, Rasle-*bolo*, etc. Moreover, there are also just good old regular *bolos*, where people live normal, reasonable and healthy lives (whatever those are).

The diversity of cultural identities destroys modern mass culture and commercialized fashions, but also the standardized national languages. As there is no centralized school system, every *bolo* can speak its own language or dialect. These can be existing languages, slangs, or artificial languages. Thus the official languages, with their function as a means of control and domination, decay, and there results a kind of Babylonian chaos, i.e., an ungovernability through dysinformation. As this linguistic disorder could cause some problems for travellers, or in emergencies, there is *asa'pili* — an artificial vocabulary of some basic terms that can be easily learned by everybody. *asa'pili* is not a real language, for it consists only of a few words (like: *ibu, bolo, sila, nima*, etc.), and their corresponding signs (for those incapable of or refusing verbal speech). With the help of *asa'pili*, every *ibu* can get anywhere the basic necessities like food, shelter, medical care, etc. If it wants to understand better a *bolo* speaking a foreign language, the *ibu* will have to study it. As the *ibu* now has a lot of time, this should not prove such a problem. The natural language barrier is also a protection against cultural colonization. Cultural identities cannot be consumed in a superficial way — you really do have to get acquainted with all the elements, spend some time with the people.[10]

KODU

The *kodu* is the agricultural basis of the *bolo's* self-sufficiency and independence. The type of agriculture, the choice of crops and methods is influenced by the cultural background of each *bolo*. A Vege-*bolo* would specialize in vegetables, fruits, etc., instead of cattle-raising. An Islamo-*bolo* would never deal with pigs. A Franko-*bolo* would need a large chicken yard, fresh herbs and lots of cheese. A Hash-*bolo* would plant cannabis, a Booze-*bolo* malt and hops (with a distillery in the barn), an Italo-*bolo* needs tomatoes, garlic and oregano. Certain *bolos* would be more dependent upon exchange, as their diet is very diversified. Others, with a more monotonous cuisine, could almost entirely rely on themselves.

Agriculture is part of a *bolo's* general culture. It defines its way of dealing with nature and food. Its organization cannot then be described on a general level. There might be *bolos* where agriculture appears as a kind of "work," because other occupations there would be considered more important. Even in this case, agricultural work wouldn't put grave limits on every single *ibu's* freedom: the work would be divided among all the members of the *bolo*. This would perhaps mean a month of agricultural work per year, or 10% of the available "active" time. If agriculture is a central element of a *bolo's* cultural identity, there's no problem at all: it would be a pleasure. In any case, everybody would have to acquire some agricultural know-how, even those who do not consider it

crucial for their cultural identity, because it is a condition for any *bolo's* independence. There won't be food stores, nor supermarkets, nor (unfairly) cheap imports from economically blackmailed countries. There won't be any centralized distribution by a state apparatus either (e.g., in the form of rationing). The *bolos* really have to rely upon themselves.[11]

The *kodu* abolishes the separation of producers and consumers in the most important domain of life: the production of food. But *kodu* isn't just this, it's the whole of the *ibu's* intercourse with "nature" — i.e., agriculture and "nature" cannot be understood as two separate notions. The notion of "nature" appeared at the same moment we lost our direct contact with it, as we became dependent upon agriculture, economy and the State. Without an agricultural basis for self-sufficiency, the *ibus* or *bolos* are basically exposed to blackmailing — they might have as many "guarantees," "rights," or "agreements" as they like, it's all just written on the wind. The power of the State is ultimately based upon its control over food supply. Only on the basis of a certain degree of autarky can the *bolos* enter into a network of exchange without being exploited.

As every *bolo* has its own land, the division between rural and urban is no longer so pronounced. The conflict of interest between farmers struggling for high prices and consumers demanding cheap food no longer exists. Moreover, nobody can be interested in waste, artificial shortages, deterioration, maldistribution, or planned obsolescence of agricultural products. Everybody is directly interested in the production of qualitatively good and healthy food, because they produce and eat it themselves and they're also responsible for their own medical care (see *bete*). Careful treatment of the soil, the animals and themselves becomes self-evident, for every *bolo* is interested in long-term fertility and the preservation of resources.

The use of land or other resources and their distribution among *bolos* must be discussed and adapted carefully. There are a lot of possible solutions, according to the situation. For pure countryside *bolos* (Agro-*bolos*) there are few problems, since they can use the surrounding land. For *bolos* in larger cities, it can be useful to have small gardens around the houses, on roofs, in courtyards, etc. Around the city there would be a garden zone, where every *bolo* would have a larger plot for vegetables, fruits, fish ponds, etc., i.e., for produce that is needed fresh almost every day. These gardens could be reached by foot or bicycle within minutes, and the quantities needing special transport would be relatively low. The real agricultural zone, larger farms of up to 80 hectares (200 acres) or several farms of smaller size, could be about 15 kilometers or so from the city-*bolo*. (Particularly in the case of certain cultures using lakes, peaks, vineyards, hunting grounds, etc.) These *bolo*-farms would specialize in large-scale production of durable foods: cereals, potatoes, soya, diary products, meat, etc. Transportation would be on the scale of tons (by chariot, trucks, boat, etc.). For the *kodu* of larger cities, a system of three zones could be practical:[12]

Zones I, II, III

For the easy functioning of *kodu*, the actual depopulation of larger cities with more than 200,000 inhabitants should continue or be encouraged by *bolos*. In certain areas, this could result in a re-population of deserted

villages. There might be pure Agro-*bolos*, but, in general, the *ibu* would not have to choose between city or country life. The *bolo*-farms or hamlets also have the function of country houses or villas, and at the same time every "farmer" would have a townhouse *bolo*. With the *kodu* system the isolation and cultural neglect of rural regions can be compensated, so that the rural exodus that is today ruining the equilibrium of much of the world can be stopped and inverted. The positive aspects of farm life can be combined with the intense urban life style. The cities would become more city-like, livelier, and the countryside would be protected against its ruin by highways, agro-industries, etc. No farmer would have to stick to his land and be enslaved by his cows. Every city-dweller would have a "cottage" in the country, without being confined to campgrounds or monotonous motels.

YALU

The *bolos* tend to produce their food as close to their central buildings as possible in order to avoid long distances for trips and transportation, which of course mean wastes of time and energy. For similar reasons there will be much less importation of petroleum, fodder and fertilizers. Appropriate methods of cultivation, careful use of the soil, alternation and combination of different crops are necessary under these conditions. The abandonment of industrialized large-scale agriculture doesn't necessarily result in a reduction of output, for it can be compensated by more

intensive methods (since there is a larger agricultural labor-force) and by the preference for vegetable calories and proteins. Corn, potatoes, soya and other beans can guarantee in their combination a safe basis for alimentation.[13] Animal production (which eats up immense amounts of exactly the above-mentioned crops) will have to be reduced and de-centralized, as to a lower degree will dairy production. There will be enough meat, but pigs, chickens, rabbits, and sheep will be found around the *bolos*, in courtyards, running around in the former streets. So scraps of all kinds can be used in a "capillary" way to produce meat.

Will the *bolo'bolo* cuisine be more monotonous? Will gastronomy decay, since the exotic importation and mass-production of steaks, chicken, veal, filets, etc., will be drastically reduced? Will there be a new Dark Ages for gourmets? It's true that you can find a large variety of foods in A-worker supermarkets — coconuts in Alaska, mangoes in Zurich, vegetables in the winter, all kinds of canned fruits and meat. But at the same time indigenous food is often neglected in spite of its freshness and quality. Whereas the variety of locally produced food is reduced (for reasons of low output, or because its cultivation is too intensive under certain economic conditions), there are costly importations of low-quality, tasteless, lame, pale and watery produce from areas where labor-power is cheap. It is a fake variety, and for just this reason the newer French high cuisine has turned to *cuisine du marché*, i.e., using food that's fresh and locally produced. Mass food production and international distribution is not only just nonsense and a cause of the permanent world-hunger crisis, it also just doesn't give us good food.

Real gastronomy and the quality of nutrition are not dependent on exotic importations and the availability of steaks. Careful breeding and cultivation, time, refinement and invention are much more important. The nuclear-fam-

ily household is not adapted to these requirements: mealtimes are too short and the equipment too poor (even if highly mechanized). It forces the house-"wife" or other family members to short cooking times and simple preparation. In large *kana* or *bolo* kitchens, there could be an excellent (free) restaurant in every block, and at the same time a reduction of work, waste and energy. The inefficient low-quality small household is just the counterpart of agro-industrialization.

In most cases cooking is an essential element of the cultural identity of a *bolo*, and in this context it's not really work but part of the productive, artistic passions of its members. It's exactly cultural identity (*nima*) that brings foreward variety in cooking, not the value of the ingredients. That's why a lot of very simple (and often meatless) dishes of a country or a region are specialties in another place. Spaghetti, pizza, moussaka, chili, tortillas, tacos, feijoada, nasi-goreng, curry, cassoulet, sauerkraut, goulash, pilav, borsht, couscous, paella, etc., are relatively cheap popular dishes in their countries of origin.

The possible variety of cultural identities in the *bolos* of a given town produces the same variety of cuisines. In a city there are as many typical *bolo*-restaurants as there are *bolos*, and the access to all kinds of ethnic or other cuisines will be much easier. Hospitality and other forms of exchange allow an intense interchange of eaters and cooks between the *bolos*. There is no reason why the quality of these *bolo*-restaurants (they might have different forms and settings) shouldn't be higher than those currently existing, particularly since stress will be reduced, there will be no need for cost calculations, no rush, no lunch or dinner hours (meal times will also depend on the cultural background of a given *bolo*). On the whole there will be more time for the production and preparation of food, as that's part of the essential self-definition of a *bolo*. There won't be any food

multi-nationals, any supermarkets, nervous waiters, overworked house-wives, cooks on eternal shifts....

Since the freshness of ingredients is crucial for good cuisine, gardens near the *bolo* are very practical (in zone 1). The cooks can raise a lot of ingredients directly near the kitchen, or get them in five minutes' time from a nearby garden. There will be a lot of time and space for such small-scale cultivation. Many streets will be converted or narrowed, car garages, flat roofs, terraces, decorative lawns, purely representational parks, factory areas, courts, cellars, highway bridges, empty lots, all will yield a lot of ground for herb gardens, chicken yards, hogpens, fish and duck ponds, rabbit hutches, berries, mushroom cultures, pigeonries, beehives (better air quality will help many of these), fruit trees, cannabis plantations, vines, greenhouses (during the winter they can serve as an insulation buffer), algae cultures, etc. The *ibus* will be surrounded by all kinds of molecular food production. (And of course dogs are edible, too.)

The *ibus* will have enough time to collect food in woods and other uncultivated areas, Mushrooms, berries, crayfish, mussels, whitings, lobster, snails, chestnuts, wild asparagus, insects of all kinds, game, nettles and other wild plants, nuts, beeches, acorns, etc. can be used for the cooking of surprising dishes. Whereas the basic diet can be (depending on the *bolo's* cultural background) monotonous (corn, potatoes, millet, soya), it can be varied with innumerable sauces and side dishes. (If we even assume for the moment a purely "ecological" minimal-effort attitude.)

Another enrichment of the *bolo*-cuisine is brought to them by traveling *ibus*, guests or nomads. They introduce new spices, sauces, ingredients, and recipes from far countries. As these kinds of exotic products are only needed in small quantities, there is no transportation problem and they will be available in more variety than today. Another

possibility for every *ibu* to get to know interesting cuisines is traveling; since *ibus* can take advantage of hospitality everywhere, they can taste the original dishes for free. Instead of transporting exotic products and specialities in a mass way, and with the subsequent deterioration of ambience, it's more reasonable to make, now and then, a gastronomic world tour. As the *ibu* has all the time it wants, the world itself has become a real "supermarket."

Preservation, pickling, potting, drying, smoking, curing and deep-freezing (which are energically reasonable for a whole *kana* or *bolo*) can contribute to the variety of food all over the year. The larders of the *bolos* will be much more interesting than our refrigerators nowadays. The different sorts of wine, beer, liquor, whiskey, cheese, tobacco, sausages, and drugs will develop into as many specialities of certain *bolos* and will be exchanged among them. (As it was in the Middle Ages, when every monastery had its own specialty.) The wealth of pleasures that has been destroyed and levelled out by mass production can be reclaimed, and networks of personal relationships of connoisseurs will spread over the whole planet.

SIBI

A *bolo* needs not only food, it needs things. Whatever concerns the production, use or distribution of things is called *sibi*. Thus *sibi* includes: buildings, supplies of fuel, electricity and water, the production of

tools and machines (mainly for agriculture), clothing, furniture, raw materials, devices of all kinds, transportation, crafts, arts, electronic hardware, streets, sewage, etc.

Like agriculture (*kodu*), so too fabriculture (*sibi*) depends on the cultural identity of a given *bolo*. A basic part of the *sibi* will be the same in all *bolos:* maintenance of buildings, simple repairs of machines, furniture, clothing, plumbing, roads, etc. A *bolo* will be much more independent than an actual neighborhood or even a family household. As there is no interest in producing defective, disposable or low-quality products, there will be fewer repairs. Due to the solid and simple design of things, repairs will also be easier, defects will have less severe consequences. The ability to do the basic craftsman's work in the *bolo* itself is also a guarantee of their independence and reduces waste of energy and time (electricians or plumbers don't have to travel across the whole town). The *bolo* is large enough to allow a certain degree of specialization among its members.

The main content of *sibi* will be the expression of typical productive passions of a *bolo*. Productive passions are in turn directly linked to a *bolo's* cultural identity. There might be painter-*bolos*, shoemaker-*bolos*, guitar-*bolos*, clothing-*bolos*, leather-*bolos*, electronics-*bolos*, dance-*bolos*, woodcutting-*bolos*, mechanics-*bolos*, aeroplane-*bolos*, book-*bolos*, photography-*bolos*, etc. Certain *bolos* won't specialize and will do many different things, others would reduce the production and use of many things to a minimum (Tao-*bolo*). Since people aren't working for a marketplace, and only secondarily for exchange, there is no longer any distinction between crafts/arts, vocation/job, working time/free time, inclination/economic necessity (with the exception of some basic maintenance work.) Of course, there will be exchange of these typical products and performances between *bolos*, as is the case for agricultural specialties. By means of gifts,

permanent agreements, through pools of resources (*mafa*) and in local markets they will circulate and will be compared to others at special fairs.

In the context of a *bolo* or even a *tega* (larger neighborhoods, towns), craftsmen's or small industrial production will be under the direct control of the producers, and they will be able to know and influence the whole process of production. Goods will have a personal character; the user will know the producer. So defective goods can be brought back, and there will be feedback between the application and the design, allowing for the possibility of improvement and refining. This direct relationship between producer and consumer will yield a different type of technology, not necessarily less sophisticated than today's mass-industrial technology, but oriented towards specific applications (custom-made prototypes), independence from big systems (interchangeability, "smallness"), low-energy consumption, easy repairability, etc.[14]

Since the field for the production and use of things is more manifold and less subject to "natural" limitations than is agriculture, the *bolos* will be more dependent on exchange and co-operation in this sector. Think of water, energy, raw materials, transportation, high tech, medicine, etc. In these fields the *bolos* are interested in coordinating and cooperating on higher social levels: towns, valleys, cities, regions, continents — for raw materials, even world-wide. This dependence is inevitable, because our planet is just too populated and such interactions are necessary. But in this sector, a *bolo* can only be blackmailed indirectly, on a mid-term level (it has got *tactical autarky*). Moreover, it has the possibility of directly influencing larger communities by means of its delegates (see *dala*). Industrial democracy — as this system could be called — must be based on the will of the users, whereas the producers determine the conditions of work.

Cooperation in certain fields is also reasonable from the point of view of energy. Certain tools, machines or equipment just can't be used in a single *bolo*. Why should every single *bolo* have a mill for cereals, construction machinery medical laboratories, big trucks? Duplications here would be very costly and demand a lot of unnecessary work. Common use of such equipment can be organized bilaterally or by the townships and other organisms (see *tega, vudo, sumi*) with machine pools, small factories, deposits of materials, specialized workshops. The same solution is possible for the production of necessary goods that are not or cannot be manufactured in a *bolo* (because there happens to be no shoemaker-*bolo* in town). So *ibus* from different *bolos* can combine, according to their own inclinations, in neighborhood or city workshops. If there are no *ibus* inclined to do such work, and if at the same time the given community insists upon its necessity, the last solution is compulsory work (*kene*): every *bolo* is obliged to furnish a certain amount of labor to accomplish such tasks. This could be the case for crucial but unsatisfactory jobs like: guarding shut-down nuclear-power plants, cleaning the sewage system, road maintenance, pulling down and removing useless highways and concrete structures, etc. Since compulsory work will be exceptional and based on rotated shifts; it cannot strongly interfere with the *ibu's* individual preferences.

⟇ PALI

A *bolo's* independence is in fact determined by its degree of self-sufficiency in energy supply. Agriculture and fabriculture can be considered two methods to resolve this problem.[15] Energy (*pali*) is needed for agriculture itself (tractors), for transportation, for heating and cooling, for cooking, for mechanical applications and for energy-production itself. *bolo'bolo* is not necessarily a low-energy civilization; i.e., low-energy consumption is not motivated by "ecological" efforts, but a mere consequence of cultural diversity, smallness, avoidance of work-intensive processes, lack of control and discipline. High-energy systems afford continuous attention, control of controllers, reliability, since the risk of breakdowns is high. *bolo'bolo* will need much less energy, because it is just a different life-style — or. what is better, a variety of lifestyles, each with a different energy need.

Local self-sufficiency, communal life in *bolos*, time instead of speed will all reduce traffic, the consumption of fuel for heating, and all kinds of mechanical applications. A large portion of energy is needed today to bring together things or people which have been separated by the functions of a centralized system: home and workplace, production and consumption, entertainment and living, work and recreation, town and country. Energy consumption rises in proportion to the isolation of single persons and nuclear families. The size and structure of *bolos* permits more achievements with less energy consumption, for different applications will also complement and support one another. The *bolos* can apply the different sorts of energy, each in the best way. Electricity will be used for lighting, electronic equipment, mechanical energy and some means of transportation (railroads, tramways). The basic supply of energy can be produced in the *bolo* itself (especially for lighting)

by wind generators, solar cells, small river-power plants, bio-gas generators, etc. Passive solar energy, collectors, geo-thermic systems can be used for heating and hot water. Fuels are only to be used to achieve high temperature: for cooking (bio-gas, wood, coal, gas), for steam engines (trucks, boats, generators), and for some combustion engines (gasoline, diesels, kerosene for ambulances, rescue planes, fire engines, emergency vehicles of all kinds).

A *bolo* is also an integrated energy system, where local and external resources can be combined. The waste heat of ovens or machines in workshops can be used for heating, because living and workplace are identical in about 80% of the cases. A lot of heated rooms can also be used communally (e.g., baths, hot tubs, drawing rooms, saunas, "restaurants"). Excrement and garbage can be transformed into bio-gas (methane) instead of polluting the waters. The size of the *bolos* (they're relatively large for this purpose) facilitates an efficient use and distribution of energy, since installations and even electronic control systems are in a reasonable relation to the necessary output. (Which just isn't the case in single buildings or family households: most new "alternative" technologies that are actually applied to single houses are pure luxury.)

In warm climates, a *bolo* could be up to 90% energy independent; in moderate and cold zones, between 50% and 80%. The *bolos* cooperate between themselves and the rest is taken care of by larger communities like townships and smaller regions (*tega* and *vudo*). On a higher level, the autonomous regions (*sumi*) conclude agreements on importation/exportation of energy (electricity, coal, petroleum). Moreover, there will be a world-wide coordination for the distribution of fossil fuels (see *asa'dala*).

High energy consumption seems to be linked to comfort, a high standard of living, mobility — so will there be

"hard times" when it is drastically reduced? Not at all. Most energy today is used to guarantee the normal industrial work day, and not for individual pleasures. The rhythm of this work day (9-to-5 or else) determines peak consumption, the necessity of a quick and standardized climatization (21 degrees centigrade and 55% humidity). As work is at the center of everything, there's no time for dealing directly with the "energy elements" of fire, wind, water, and fuels. Climate, the daily and seasonal rhythm that could bring a lot of diversity and pleasure, is seen as only the source for trouble, since it disturbs work (snow in the winter, rain, darkness, etc.). So there is a kind of fake comfort in "environmental control" that causes an immense expenditure of social effort, but doesn't really yield any real pleasure or enjoyment in warmth or coolness. (It's also visible in the need for certain people to have a chimney-place right by the central heating radiator: warmth isn't just a certain calculation in Celsius or Fahrenheit.)

The production and use of energy will be linked more to natural conditions. In the winter, there won't be a kind of artificial spring in all rooms; maybe the temperature will be only about 18 degrees centigrade in certain rooms, and only in some really lived-in rooms or salons will it be warmer. The *ibus* may wear more pullovers, live a little close together, go to bed earlier sometimes, eat more fatty dishes — they'll live "winterly," like Minnesota farmers, or those who take ski vacations in the mountains. The cold *per se* is not a real nuisance: ask an Eskimo. Only under the conditions of the standardized work day does it seem impossible. Winter also means that there is less work (agriculture is resting), and more time to deal with bread ovens, heating systems, curling up with books or each other, etc.

Some *ibus* or *bolos* can avoid winter problems by migrating to milder zones, just like certain birds. Since they

will be gone for months, this could be energy efficient in spite of the travel. *bolos* could have some hibernating agreements with each other, and vice versa for the summer. There could be exchanges between Scandinavian and Spanish *bolos*, between Canadian and Mexican ones, between Siberian and South Chinese, between Poland and Greece, between Detroit and Dallas, etc.

SUVU

Besides food and energy, water is a crucial element for the survival of the *ibu* (if it so desires). Whereas in many parts of the planet water supply is an unsolved problem, water's wasted in other parts mainly for cleaning and disposal (flushing away excrement or garbage). It's not used in its specific quality as water (*suvu*), but for easy transportation as sewage.

Most of today's washing, flushing, rinsing, cleaning and showering has nothing to do with physical well-being or with the enjoyment of the element *suvu*. The shower in the morning isn't taken for the pleasure of feeling running water, but for the purpose of waking us up and disinfecting us, making our reluctant bodies ready for work. Mass production causes the danger of mass infections, and requires hygienic discipline. It's part of the A-worker maintenance of labor-power for the Work Machine. Washing, the daily change of underwear, white collars, these are all just rituals of work-discipline, serving as the means of

control for the bosses to determine the devotion of subordinates. There isn't even a direct productive or hygienic function to many of such tasks, they're just theater of domination. Too frequent washing and extensive use of soaps, shampoos, and deodorants can even be a health hazard — they damage the skin and useful bacterial cultures are destroyed. This disciplinary function of washing is revealed when we stop shaving during vacations, or change our underwear less frequently, or wash less compulsively. Dirt and the right to be dirty can even be a form of luxury. In many parts of this planet the relationship with "dirt" (dysfunctional substances) is neurotically charged mainly because of our education or by the disciplinary function of "cleanliness." But cleanliness is not objective, but culturally determined. External cleanliness is a form of repression of internal problems. But dirt can never be removed from this world, only transformed or displaced. (This is particularly true for the most dangerous sorts of dirt, like chemical or radioactive wastes, which the cleanliness syndrome conveniently overlooks.) What is removed from the household as dirt appears afterwards in the water, mixed with chemical detergents to create an even more dangerous kind of dirt, if a little less visible than before. For this purpose, purification plants are built which demand the production of huge quantities of concrete, steel, etc. — even more dirt, caused by industrial pollution. The damage (and work) that is caused by exaggerated cleaning is in no sane relationship with the (imaginary) gain of comfort. Cleaning work not only produces dirt in the form of polluted waters, but also exhaustion and frustration in the cleaning workers. (Actually, tiring work and drudgery is the most important form of environmental pollution — why should a polluted body care for the preservation of "nature?")

As the disciplinary functions of washing and most of the large industrial processes that need water will disappear, the *bolos* can reduce the actual consumption of water to at least one third or less. Small communities and processes are "clean" because all their components and influences can be carefully adjusted and all substances used in their specific way. As the *bolo* is large enough to make recycling easy and efficient, most "dirt" or "garbage" can be used as raw materials for other processes. Air pollution will be low, pollution by regular work as well, and there is a direct interest in avoiding cleaning work at the source, since it must be done directly by those who cause it.

Many *bolos* will be able to achieve self-sufficiency in water supply by collecting rain water in tanks or by using springs, rivers, lakes, etc. For others, it'll be more convenient to organize water supply in the frame of towns, valleys, islands, etc. A lot of *bolos* in arid regions will need the help of other *bolos* (on a bilateral or world-wide basis) to drill wells or build cisterns, In the past the problem of water supply has been resolved under extremely difficult conditions (deserts, islands, etc.). The actual world-wide "water-crisis" is mainly due to over-urbanization, the destruction of traditional agricultural patterns, and the inappropriate introduction of new technologies and products. The use and sufficient availability of water is linked to the cultural background; it's not just a technical issue.

ᛒ GANO

Bolo'bolo isn't only a way for the *ibu* to conquer more time, but also a way to get more space (*gano*). Shop roofs, garages, offices, warehouses, many streets and squares, factory buildings, all will become available for new utilization by *bolos* and *ibus*. Since there will be no real-estate property, no laws for construction, all kinds of private restrictions, speculation, over- and underutilization disappear. The *bolos* can use their buildings as they like, they can transform them, connect them, paint them, subdivide them, all according to their cultural background (*nima*). Of course problems can arise, conflicts over which *bolo* gets which buildings and space in general. These problems can be discussed and resolved in the framework of larger communities (neighborhoods, cities, even regions), where every *bolo* is represented by its delegates (see *tega, fudo, sumi*). Even if there are serious disputes, nobody can claim control over buildings he or she doesn't actually use. Contrary to today's property system, this can prevent most abuses.

The *bolos* won't primarily be interested in building new structures, but in using existing ones in new ways, and in re-using all those construction materials that have been abundantly accumulated in many places. The *bolos* will prefer local materials, since transportation requires valuable energy and labor. In this context, forgotten know-how can prove very useful and should be revived: construction with clay, adobe, palm leaves, wood, reeds, etc. Construction methods are also linked to the energy system of a given *bolo*, e.g., for passive solar energy, insulation zones, greenhouses, heating and cooling. The international architectural style of steel, glass, and concrete is very energy-consumptive, and inappropriate for most climates. The same is true for standardized, one-family houses, particularly those forming dull and wasteful suburban sprawls so lacking in communal or

cultural function. New utilization of such buildings or neighborhoods by *bolos* is problematic, but still possible by means of certain adaptations and modifications. Multi-story buildings can be partially topped off with terraces for planting and provided with glass greenhouses to reduce energy loss. The colder northeast or northwest sides of large buildings can be closed off in harsh winter weather, or used as storage spaces or workshops (heating would require too much energy). Between the stories of adjacent buildings stairs can be built in order to connect rooms to larger households (*kana*).

Suburban one-family houses can be connected by arcades, intermediate buildings, communal halls, and workshops, and be condensed to *bolos*. Other houses will be torn down to make space for gardens and to get necessary building materials on the spot.

As all *bolos* can express their cultural identity in their architecture, the actual monotony of many neighborhoods will disappear. The urban areas will become lively and mani-fold again, above all because the division between downtown areas and suburbs will disappear. There will be no distinction between cultural and merely reproductive neighborhoods. At any time (even at night and on Sundays) — some *bolos* will possibly stick to such perversities as "weeks,"

"months" or "years" — there will be *ibus* in the streets, at the corners, in the courtyards. With the regular work day gone, general periods of rest will also disappear. There are no stores (except for the neighborhood market: see *sadi*) and therefore no closing hours or empty streets. The *bolos* are always "open."

```
[ - - ]  former houses and streets

[   ]    retained structures

[|||]    added structures
```

Nesting in, variety, the need for permanent transformations and adaptations to changing cultural identities will give the cities a rather "chaotic," medieval, or oriental image (we'll be reminded of the times when they used to be lively). Improvisation, provisional structures of all kinds, a wide diversity of materials and styles will characterize the architecture. Tents, huts, arcades, overpasses, bridges, towers and turrets, ruins, hallways, etc., everything will be very common, since different parts of the *bolos* should be reach-

able without exposure to the weather. Adjacent *bolos* may opt for common institutions. Walking will be the most frequent form of travel.

On the whole there will be more space for the *ibus* than the present permits. Immense warehouses and commercial spaces will be available, and a lot of space will be in common use. Every *ibu* will find room for its workshop, atelier, studio, exercise room, library, laboratory. The distribution of living space cannot be regulated by "laws" (for example, "every *ibu* is entitled to forty square meters"), since needs are determined by cultural backgrounds. Certain lifestyles require dormitories, others require individual cells, others group rooms, chapels, hammocks, towers, caves, refectories, many walls, few walls, high ceilings, cross vaults, longhouses, steep roofs, etc.

Although the real causes for many forms of social violence (mugging, rapes, assaults) are not exclusively due to the anonymity of today's neighborhoods, the permanent animation of public and "private" spaces by local *ibus* may be an efficient contribution to make such acts impossible. The bolos are also the condition for a kind of spontaneous social control, a sort of "passive police".... The "disadvantage" of a system that is based on personal contacts consists in being known by practically everyone, or by being recognized immediately as a stranger. You cannot easily afford to ruin your reputation.... On the other hand, every *bolo* will have its own moral standards.

BETE

Strictly speaking, it's impossible to define health care, *bete*, as a separate task. Illness or health are not just dependent on medical interventions, but much more on social factors, on the way of life as a whole. *bolo'bolo* itself is the most important contribution to health, for it eliminates a lot of diseases that are direct or indirect effects of industrial society: traffic accidents, industrialized mass wars, stress and environmentally induced diseases, many occupational hazards and accidents, psychosomatic and psychological problems. Work and stress are the main cause of many diseases, and their reduction is the best medicine.

The *bolos* themselves will decide on the definition of health and sickness (except in the case of epidemics). Like beauty, morality, truth, etc., the definition of "well-being" varies with the cultural background. If some *ibus* choose ritual mutilations or beauty scars, nobody will try to stop them. General distinctions between "normal" and "crazy" will be impossible. The *bolos* will decide also on what kinds of medicines they find appropriate for the context of their own lives.[16]

Every *bolo* will be able to treat simple wounds and frequent illnesses on its own. It can set up its own *bolo*-clinic and arrange a permanent team of experienced *ibus* who are on call. (Miraculously, in most advanced industrial countries there is one doctor for about every 500 persons….) There might be special rooms for medical care, a pharmacy holding the 200 or so most frequent drugs, some beds, emergency kits and special means of transportation. On the whole, the medical help will be faster and better than today, because nobody is left alone and forgotten.

In a *bolo* sick and healthy *ibus* don't live separate lives (all *ibus* are more or less ill or healthy). Bed patients, chronically sick persons, the elderly, parturient, mentally ill per-

sons, invalids, the handicapped, etc., can stay in their *bolo* and will not have to be isolated in institutions. The concentration and isolation of persons unfit for work (that's been our operative definition of illness) into hospitals, old folks' homes, psychiatric hospitals, reformatories, etc., is the other aspect of the weakness of the nuclear family, one that rationalizes the distinction between work and household. Even children become a problem for it.

It's also possible that certain *bolos* transform a disease or a "defect" into an element of their cultural identity. Blindness can become a way of life for a *bolo* where everything is specially arranged for blind persons. Blind-*bolos* and handicapped-*bolos* could also be combined, or there could be deaf-mute *bolos* where everybody communicates through sign language.

Maybe there will "crazy"-*bolos*, diabetes-*bolos*, epileptic-*bolos*, bleeder-*bolos*, etc. Maybe not.

Whereas *bolos* can be largely self-sufficient in basic medical assistance, they need more sophisticated institutions for special cases. In emergencies, heavy accidents, for complicated diseases and for the prevention of epidemics there will be a graded medical system that contains also the most advanced medical techniques. On the level of cities (*vudo*) or regions (*sumi*) the *ibus* will have access to advanced medical treatment. The overall expenditures for medical care will nevertheless be much lower than today. In the rare cases of emergencies, ambulances, helicopters and planes will be faster than under the present system, and there's no reason why they shouldn't be used.

There are good chances that the *ibus* will be in better health than we are today. But there won't be an official medical definition of health, and longevity won't be a general value. (Today, longevity is simply an official value because it means fitness for labor and long use by the Work Machine.) There are tribes where life is relatively short but

very interesting in other aspects, and other cultures where long lives are important cultural values. There are simply different conceptions of life, different calculations between adventure and length. Some are more interested in risk, others in tranquility. There can be *bolos* for each.

NUGO

The *nugo* is a metallic capsule an inch-and-a-half long and half-an-inch in diameter, secured by a twist-combination lock whose seven-digit number is known only by its bearer (and maybe his or her best friend):

This metallic container encloses a pill of an immediately deadly substance. Every *ibu* gets its *nugo* from its *bolo*, as is the case for *taku*. The *ibu* can wear its *nugo* together with the keys to its property trunk on a chain around its neck so that it's always ready for use. Should the *ibu* be incapable of opening the capsule and swallowing the death pill (due to paralysis, injury, etc.), the other *ibus* are obliged to help it (see *sila*).

If the *ibu* is sick of *bolo'bolo*, of itself, of *taku*, *sila*, *nima*, *yaka*, *fasi*, etc., it can always feel free to quit the game definitely and escape from its (improved, reformed) nightmare.

Life shouldn't be a pretext to justify its responsibility towards *bolo'bolo*, society, the future, or other illusions.

The *nugo* reminds the *ibu* that *bolo'bolo* finally makes no sense, that nobody and no form of social organization can help the *ibu* in its loneliness and despair. If life is taken too seriously, it equals hell. Every *ibu* comes outfitted with a return ticket.

PILI

If the *ibu* decides to stick around, it will enter into a variety of forms of communication and exchange with its (surrogate) fellow-*ibus*. It will blink at them, talk to them, touch them, make love to them, work with them, tell them about its experiences and knowledge. All these are forms of *pili*, communication, education, exchange of information, expression of thoughts, feelings, desires.

The transmission and development of knowledge and cultural identities is itself part of such a cultural background (*nima*). Every culture is at the same time its own "pedagogics." The function of cultural transmission has been usurped by specialized State institutions such as schools, universities, prisons, etc. In the *bolos* there won't be such institutions; learning and teaching will be an integrated element of life itself. Everybody will be a student and a teacher at the same time. As the young *ibus* will be around the older ones in the *bolo*-workshops, kitchens,

farms, libraries, laboratories, etc., they can learn directly from practical situations. The transmission of wisdom, know-how, theories, styles will always accompany all productive or reflective processes. Everything will be "disturbed" by learning.

With the exception of the basic *bolo'bolo* terms (*asa'pili*), there won't be compulsory literacy, no "three R's." The *bolos* certainly can teach reading, writing, and arithmetic to their young *ibus* if they consider it necessary to their culture. It might be that certain *bolos* develop special pedagogic passions and skills so that young *ibus* from other *bolos* can go there and learn certain matters. Or, if there is enough consensus in a neighborhood or a city (*tega, vudo*), a kind of school system can be organized. But all this will be completely voluntary and differ from place to place. There will be no standardization of school systems, no official programs.

On the level of more specialized and larger enterprises (regional hospitals, railroads, electric power plants, small factories, laboratories, computer centers, etc.), knowledge can be acquired on the job. Every engineer, doctor or specialist will have some apprentices, and deal with them on a personal level. Of course, they can arrange special courses for them and send them to other "masters" or specialized *bolos*. Knowledge will circulate freely and on a practical, personal, voluntary basis. There won't be standardized selections, grades, diplomas, titles, etc. (Everybody can call him or herself "doctor" or "professor" if it's their wish to.)

In order to facilitate the circulation of knowledge and know-how, neighborhoods or larger communities can organize centers of cultural exchange, markets of knowledge. In such "reciprocal academies" everybody could offer lessons or courses and attend others. Former school buildings

or lofts could be used for such purposes and be adapted by adding arcades, colonnades, baths, bars, etc. In the buildings there could be theaters, cinemas, cafes, libraries, etc. The "menu" of such academies could also be a part of a local computer information pool, so that every *ibu* could also find out where it can get what kind of training or instruction.

As the *ibus* have a lot of time at their disposal, the scientific, magical, practical and playful transmission of capabilities will expand considerably. Expansion of its cultural horizon will probably be the main activity of the *ibu*, but it will be without any formal character. The disappearance of centralized, high-energy, high-tech systems will also make superfluous centralized, bureaucratic, formal science. But there's no danger of a new "dark age." There will be more possibilities for information and research; science will be in the reach of everyone, and the traditional analytical methods will be possible, among others, without having the privileged status that they have today. The *ibus* will carefully avoid dependency upon specialists, and will use processes they master themselves.

As is the case with other specialities, there will be certain *bolos* or "academies" (*nima'sadi*) that become famous for the knowledge that can be acquired there, and which will be visited by *ibus* from all over the world. Masters, gurus, witches, magicians, sages, teachers of all kinds with big reputations (*munu*) in their fields will gather students around them. The world-wide rules of hospitality (*sila*) encourage this type of "scientific" tourism much more than can be done under today's allowances. University will become universal.

Communication in itself will have a different character under the conditions of *bolo'bolo*. Today it is functional and centralized, hardly oriented towards mutual understanding, horizontal contacts or exchanges. The centers of information (TV, radio, publishing houses, electronic data-pools)

decide what we need in order to fit our behavior to the functions of the Work Machine. As the present system is based on specialization, isolation and centralization, information is needed in order to prevent it from collapse. News originates in the fact that nobody's got the time to care about happenings in his or her own neighborhood. You have to listen to the radio to know what's happening just down the block. The less time we've got to care about things, the more information we need. As we lose contact with the real world, we depend on the fake, surrogate reality that is produced by the mass media. At the same time we lose the ability to perceive our immediate environment.

By its intensive internal interactions and mutual exchanges, *bolo'bolo* reduces the amount of not experienced events and therefore the need for information. Local news doesn't have to be transmitted by newspapers or electronic media, because the *ibus* have enough time and opportunities to exchange them orally. Chatting and gossipping on streetcorners, at markets, in workshops, etc., is as good as any local newspaper. The type of news will change anyway: no politics, no political scandals, no wars, no corruption, no activities by states or big companies. Since there will no longer be any "central" events, there will no longer be any news about them. Few things will "happen" — i.e., the everyday media-theater gets displaced from the abstract media machine into the *bolo*-kitchen.

The first victim of this new situation will be the mass press. Not only does this medium permit little two-way communication (letters to the editors are just alibis), it causes a big waste of wood, water and energy. Paper information will be limited to bulletins of all kinds, to proceedings of neighborhood or city assemblies (*dala*) and to reviews.

The "freedom of the press" will be given back to the users. There might be more reviews being published irreg-

ularly by all kinds of organisms, *bolos*, writers' collectives, individuals, etc.

The role and use of books will change, too. Mass book-production will be drastically reduced, because fewer copies will be needed to fill *bolo* libraries. Even if there were a one-hundredth scale print-run, the access to titles by individual *ibus* could be better. With *bolo*-libraries an immense waste of wood, work and time can be avoided. The single book will be of better quality and its value will be more esteemed. It will be more than just a source of information to be thrown away after use, as paperbacks often are. Purely technical or scientific information that should be available everywhere and instantly could be stored in electronic data-banks and printed out as needed. The book as an object will become once again a work of art, as in the Middle Ages. In certain *bolos* there will be calligraphic studies and illuminated copies and manuscripts will be written. As other specialties, they could be exchanged as gifts or at markets.

bolo'bolo will not be an electronic civilization — computers are typical for centralized, depersonalized systems. *bolos* can be completely independent from electronics, for their autarky in most fields doesn't require a lot of exchange of information. On the other side, the existing material and hardware could also be used by the *bolos* for certain purposes. Radio, television, computer data-pools and networks are energy efficient and permit a better horizontal contact between users than other media. Local cable-TV networks, radio stations, video libraries, etc., can be installed by local organisms (see *tega, vudo*) and remain under the control of the collective users.

When electronics is used by *bolos*, very little material is needed; there will be few parallels to the case of under-used

home computers today. A few factories (one or two per continent) could produce the necessary equipment and manage the exchange of parts. Already at this moment there's a computer terminal for every *bolo* on the planet — no more production is necessary. The telephone network could also be completed in such a way that every *bolo* could have at least one station. This means that it could be connected with regional or planetary processors or data-banks. Of course, every *bolo* would have to decide on the basis of its cultural background whether it needs such means of communication or not.

As physical transportation will often be slower, less frequent and of lower capacity than today (see *fasi*), an electronic network of communication could be quite useful. If you want to contact a *bolo* you could just make a call — so every *ibu* could reach virtually every other *ibu*. Such a network of horizontal communication will be an ideal complement to self-sufficiency. Independence doesn't have to become synonymous with isolation. For the *bolos* there's little risk of becoming dependent upon technology and specialists — they can always fall back on their own expertise and personal contacts. (Without *bolos* and relative autarky, computer technology is just a means of control by the centralized machine.)

Quick and extensive information can mean additional wealth for the *bolos*, i.e., access to a larger variety of possibilities. Single *bolos* can call different "menus" from a databank — that is, they will know how to get certain goods, services or know-how at a reasonable distance and with the required quality. Hence gifts, permanent contracts of exchange, trips, etc., all can be easily arranged without any need of money.

KENE

In the contacts with other *ibus* and *bolos*, there might arise certain agreements on common enterprises, not only exchange of information but also the organization of common work. For every *bolo* it will be voluntary to join such enterprises, but of course *bolos* who choose not to cooperate will have no right to automatically participate and take advantage of them. Social organization is a trap; in *bolo'bolo*, the price of being caught in this trap can be *kene*, external, compulsory work.

Common enterprises like hospitals, energy supplies (electricity), peak technologies, medicine, the protection of the environment, the means of communication, the water supply, mining, mass production of selected goods, big technologies (refineries, steel mills, purification plants, ship building, airplane construction, etc.) require a certain number of *ibus* ready to do such work. It's probable that most *ibus* can be found on a voluntary basis, i.e., they might even realize their productive passions in such enterprises. On the other side, this sector will be drastically re-dimensioned and entirely determined by the will of the participating communities. (Ships don't have to be built; the pace and quality of work will be defined by those who do it; there are no wages or bosses; there's no hurry or profitability.) The industrial undertakings of the bolos, towns or regions (no longer anything like "private" enterprise)

will be a relatively lame, harmless, low-productivity affair, and no longer so repulsive for those *ibus* engaged in it. Nevertheless, it's reasonable to organize some industrial plants or centralized institutions on a larger scale: a middle-sized, carefully planned and ecologically equipped steel factory is much less polluting than a melting furnace in every *bolo*-court.

So, if a certain number of bolos or other communities should decide to put up such middle-sized enterprises, and if it shouldn't be possible to find enough *ibus* inclined to do such work, what can be done? There might be a "rest," and this rest-work (*kene*) could be distributed among the participating communities and declared "compulsory." In return, they would get the goods or services they produce for "free." The amount of *kene* (social or external work) depends on the situation. Most traditional societies are acquainted with this system and in times of crises or when the economic system collapses they return spontaneously to it if they're not hindered by State intervention or property limitations. It's imaginable that a *bolo* could give 10% of its active time (i.e., 50 *ibus* per day for some hours) to common work in the township. This community (*tega*) could pass over 10% of its labor to the city (*vudo*) and so on up to planetary institutions. Inside the *bolo* there could be a system of rotation or other methods, depending upon custom and structure. The rest of the work will be mainly unqualified, dull, but somehow necessary tasks, ones that probably don't fulfill any personal vocation. For the *ibu* as an individual, even work it has consented to can't be compulsory; it can always leave, change its *bolo* or try to get its *bolo* out of such agreements. This will all be a question of reputation — *munu*. (I mean, doing compulsory work could ruin someone's reputation.)

TEGA

On the basis of communication (*pili*) and common activity (*kene*), larger communities than *bolos* are possible. The forms of such confederations, coordinations or other *bolo* clusters will be different from region to region and continent to continent. *bolos* can also exist alone (in the jungle) or in groups of two or three. They can have rather loose arrangements, can work together closely, almost "state"-like. There can be overlappings, temporary agreements, enclaves and exclaves, etc.

One basic possibility for ten to twenty *bolos* is to form a *tega*, a village, small town, a larger neighborhood, a valley, a smaller countryside area, etc. A *tega* can be determined by geographic convenience, urban organization, cultural or historic factors or simple predilection. A *tega* (let's call it "township") will fulfill certain practical tasks for its members: streets, canals, water, energy plants, small factories and workshops, public transportation, hospital, forests and waters, depots of materials of all kinds, construction, firefighters, market regulations, (*sadi*), general help, reserves for emergencies. More or less, the *bolos* organize a kind of self-administration or self-government on a local level. The big difference to such forms in actual societies (neighborhood councils, block committees, "soviets," municipalities, etc.) is that they're determined from "below" (they're not administrative channels of a centralized regime) and that the *bolos* themselves with their strong independence limit the power and possibilities of such "governments."

The township can also assume (if the *bolos* want it) social functions. It can have organs to deal with conflicts between *bolos*, to supervise duels (see: *yaka*), to found or dissolve uninhabited *bolos*, organize township-*bolos* (for *ibus* that cannot find a common life-style, but nevertheless would like to live in a bolo...). In the frame of the township, public life should be constituted in such a way that different ways of life can coexist and that conflicts remain possible but not excessively enervating. In the township other forms of life outside the bolos should find their space of living: hermits, nests of nuclear families, nomads, bums, communities, singles. The township will have the task of arranging the survival of such people, helping them conclude agreements with *bolos* concerning food, work, social activities, resources etc. A township will organize as many common institutions as the participating *bolos* wish: swimming pools, ice rinks, mini opera-houses, theatres, ports, restaurants, festivals, parties, racetracks, fairs, slaughterhouses, etc. There could also be township farms on the basis of common work (*kene*). In all this, the *bolos* will take care not to lose too much of their self-sufficiency to the township — the first step to a central state is always the most harmless and inconspicuous....

Schematic view of an urban township (*tega*):

DALA

DUDI

One of the problems of social institutions — even when they fulfill the best and most innocent functions — is that they tend to develop a dynamic of their own towards centralization and independence from their constituencies. Society always brings the risk of the return of the State, of power and politics. The best limitation to such tendencies is the self-sufficiency of the *bolos*. Without this, all other formal democratic methods must fail, even the principle of delegation from below, systems of rotation of seats, checks and balances, publicity, the right of full information, delegation by lot, etc. No democratic system can be more democratic than the material, existential independence of its members. There's no democracy for exploited, blackmailed, economically weak people.[18]

Given the autarky of the *bolos*, certain proposals that could minimize the risk of statehood can be made. Inside the *bolos*, there can't be any rules, for their internal organization is determined by their lifestyle and cultural identity.

But on the township-level (and all "higher" levels) the following procedures could be reasonable (of course, the *bolos* of every township will find their own system).

The township affairs are discussed and put to work by a township assembly (*dala*) to which every *bolo* sends two delegates. Additionally there will be two external delegates (*dudis*) from other assemblies (see below). The *bolo* delegates are appointed by lot, and half of the delegates must be of the male sex (so that there is no over-representation by women, who form the "natural" majority). Everybody participates in this casting of lots, even children. Of course nobody could supervise and enforce such a system; it could only exist as an agreement among the *bolos*.

The township assembly (*dala*) chooses two *dudis* among its members, also by lot. These external delegates will be sent by another system of lots to other assemblies (other townships, "counties," regions) of another level and another area. So a township in Lower Manhattan would send its observers into the assembly of the region (see: *vudo*) Idaho; the assembly of Duchess County would send observers into a township-assembly in Denver; the region Chihuahua (Mexico) would send observers into the assembly of a county in Texas, etc. These observers or delegates have the full right of vote and are not bound to discretion — indiscretion and interference in "foreign" affairs are in fact their task.

Such observers could destroy local corruption and introduce totally extraneous opinions and attitudes — they'd disturb the sessions. They could prevent assemblies from developing isolationist tendencies and regional egoisms.

Additionally, the assemblies of all levels could be limited in time (election for one year only), by the principle of public meeting, by transmission on TV, by the right of everybody to be heard during sessions, etc.

The delegates of *bolos* would have different statuses and would be more or less independent from instructions by their *bolos*. Their mandate would be more or less imperative — it depends on what kind of *bolo* they represent, if it's more "liberal" or more "socialized." They're also responsible for the execution of their decisions (this is another limitation of their bureaucratic tendencies) and their activity can be considered as a kind of compulsory work (*kene*).

The *dalas* of all levels cannot be compared to parliaments, governments or even organs of self-administration. They're just managing some social interstices and agreements of the *bolos*. Their legitimation is weak (lots), their independence low, their tasks locally limited and merely practical. They should rather be compared to "senates" or "houses of lords," i.e., meetings of representatives of independent units, a kind of feudal democracy. They aren't even "confederations." The *bolos* can always boycott their decisions or convoke general popular assemblies....

VUDO

The *bolos* will solve most of their problems alone or in their townships (*tegas*). But at the same time most *bolos* will have farms or other resources beyond township "limits." To arrange such things, a larger coordination of townships could be convenient in many cases. Ten to

twenty townships could organize certain tasks in the frame of a *vudo* (small region, city, county, canton, valley).

The size of such a county would have to be very flexible, depending on geographic conditions and existing structures. It will represent a functional living area for about 200,000 *ibus*, or 400 *bolos*. There would be very little transportation going beyond a *vudo*. Agriculture and fabriculture should be geographically united on this level, self-sufficient up to 90% or more. Inside a county it should be possible for every *ibu* to travel somewhere and to return the same day (and still have time to do something). In densely populated areas, this could be a surface of 50 x 50 kilometers, so any *ibu* could get around by bicycle.

A county could have the same type of tasks as a township, just on a higher scale: energy, means of transportation, high technologies, an emergency hospital, organization of markets and fairs, factories, etc. A specific task of counties should be to care for forests, rivers, mountain areas, moors, deserts — areas that don't belong to any *bolo*, that should be used commonly, and that need to be protected against damage of all kinds. A county would have more tasks in the field of agriculture, especially when dealing with related conflicts between *bolos* (who's going to get what land?).

A county can be organized around a county assembly (*vudo'dala*). Every township assembly could send two delegates (1 male, 1 female) chosen by lot (see: *dala, dudi*).

Some counties will have to be of larger size, to deal with cities of several million inhabitants. These megalopoli pose a special problem, for their urban *bolos* (easily formed) will have difficulties becoming self-sufficient in food. The approaches to this problem will be manifold. First, the large cities should be thinned out, so that unities of not more than 500,000 people can be formed. In certain cases, and for historically interesting cities (New York, London, Rome,

Paris, etc.), this cannot be done without damaging their typical image. In this case these super-counties have to conclude special agreements with surrounding counties or regions concerning the exchange of food versus certain "cultural" services (theatre, cinema, galleries, museums, etc.) for several regions. On the other side, the outer townships of such cities could reach full self-sufficiency, and thinned-out areas could at least guarantee a partial food supply for the downtown areas.

SUMI

The autonomous region (*sumi*) is the largest practical unity for *bolos* and *ibus*. Such a region can comprise an indefinite number of *bolos*, townships or counties, maybe about twenty or thirty counties, or several million people. In special cases this can be more, or even just several thousands — as in the case of isolated communities on islands, on mountains, in the ice or the desert. There are several hundred regions on this planet; most of them will be known within the same continent.

A region is principally a geographic unity: a mountain area, a region between two large rivers or mountain chains, a large island or peninsula, a coast, a plain, a jungle, an archipelago, etc. It is a unity mainly as far as transportation and getting around is concerned, and it should have enough resources to be self-sufficient. Most exchange and most communication of the *bolos* will be within the limits of such

a region. It is not an administrative, but an everyday-life, practical unit. In certain cases it corresponds to actual "states" (U.S.) or "republics" (U.S.S.R.), to duchies, provinces, official regions (Italy, France), Lander (Germany) etc. But in many of these cases, these areas are purely administrative and unpractical. In some cases they've even been created in order to tear apart or crush existing regions based on cultural, historical or other identities.

Regions are in fact not only geographic areas (in some cases this might be sufficient), they're cultural unities, like the *bolos*. There might be a common language or dialect, a history of common struggles, defeats or victories, similar lifestyles, housing forms (related to climate or topography), religions, institutions, dishes, etc. All this, and some accidents can form a kind of regional identity. On the basis of such identities, a lot of struggles in all parts of the world have taken place in this century and before: the Irish, American Indians, Basques, Corsicans, Ibos, Palestinians, Kurds, Armenians, etc. The cultural identity of a whole region might be more diversified and less typical than the one of a *bolo*; it can still be strong enough to strengthen a community. Of course, regional identity can never be a pretext to suppress *bolos* and their identity. No region should expel a *bolo*, and every adjacent *bolo* should be free to chose its region. History has demonstrated that autonomous regions not denied their own independent culture are very tolerant towards other cultural identities too. In fact, the self-sufficiency of its *bolos* is the real strength of an autonomous region. By "losing" *bolos* or townships and "winning" others, a region can continuously adapt to changing situations; there are no "hard" borders that always cause unnecessary conflicts and wars. A region is not a territory, but a living area changing with life. In the form of typical *bolos*, every region has many "embassies" in other regions (Irish *bolos* in

New York, Bronx *bolos* in Paris, Sicilian *bolos* in Burgundy, Basque *bolos* in Andalusia, etc.).

Such flexible regions are also a possibility for solving all those problems that have been caused by absurd national borders: the existing nations shaped for the purpose of control and domination will be diluted in the mass of soft regions.[20]

Specific practical tasks of regional assemblies could be: guarding shut-down nuclear installations or deposits (mine fields, barbed wire, rotating guards, MG-towers,

etc. for several ten thousand years), the maintenance of some railroads, boat lines, airlines, computer centers, laboratories, energy-exports and imports, emergency aid, help for *bolos* and townships, taking care of conflicts, participating in continental and planetary activities and institutions. Resources and personnel needed for such purposes can be delivered in the form of common work by counties, bolos or townships (*kene*).

Regional assemblies can have the most differing forms. A convenient solution could be the following: two

delegates from each county, forty delegates from twenty *bolos* chosen by lot—about sixty members. This system would prevent the discrimination of minority cultures (also cultures that are not "typical" to a region would be represented). Additionally there would be two observer-delegates (*dudis*) from other assemblies, and two delegates from each adjacent region. Thus, in the regional assembly of New York City there would be fully entitled delegates from New Jersey, Upstate New York, Connecticut, etc. (and vice versa). By means of such horizontal representation, the cooperation and mutual information exchange for regions could be encouraged, and they would be less dependent on superior levels. Several regions could as well form cooperating groups or alliances, especially in the field of transportation and raw materials. In Europe (in a loosely geographic sense) there could be about 100 regions, in the Americas 150, in Africa 100, in Asia 300, and in the rest of the world 100, about 700 regions in all.

O ASA

Asa is the name of the spaceship "Earth." The autonomous regions can be considered the different rooms of this spaceship, and most of them might be interested in joining the planetary assembly, *asa'dala*. Every region will send for this purpose two delegates (1 male, 1 female) to its meetings, taking place alternating between

(Quito and Beirut each year respectively. The planetary assembly is a forum for the regions for contacts, chatting, encounters, exchange of gifts or insults, concluding new agreements, learning languages, having parties and festivals, dancing, quarrelling, etc. Such a planetary assembly or specialized committees could take care of some planetary hobbies, such as the use of the seas, the distribution of fossil resources, the exploration of space, telecommunications, guarding dangerous deposits, intercontinental railroads, airlines, navigation, research programs, the control of epidemics, postal services, meteorology, the dictionary of a planetary auxiliary language (*asa'pili*), etc. The proceedings of the assembly will be broadcast worldwide so that all regions know what their delegates or others are talking about in Beirut or Quito. (Of course, somebody should ask these two cities whether they'd like to be hosts to such a crowd.)

A planetary assembly and its organisms can only do what the participating regions let them do. Whether they take part in it depends on their own interests. Any region can retire from planetary organisms and do without its services. The only basis of the functioning of planetary enterprises are the interests and passions of the regions. When agreements are not possible, there are problems. But due to the multiple networks of self-sufficiency, the situation should never become dangerous for a single region. In this regard factors like the reputation of a region, its historic connections, its cultural identity, its personal relationships will be as important as "practical" deliberations. (Nobody knows what "practical" really means.)

Planetary institutions will have very little influence on the everyday life of *bolos* or regions. They will deal with a certain amount of left-overs that cannot be dealt with by local communities or that have no influence on any single region at all (seas, polar areas, the atmosphere, etc.). Without firmly

established self-sufficiency for the regions, such a world confederation would be a risky experiment, and could become a new form of domination, a new Work-and-Power-Machine.

BUNI

The most common and frequent form of exchange of things between *ibus* or communities are gifts — *buni*. Things or time (for mutual help, services) will not necessarily be scarce, and the best way to deal with this abundance is waste in the form of gifts. As everyday contacts will be intensive, there will be many occasions for gifts.

Gifts have many advantages for both taker and giver. As the one who gives something determines its form and quality, it's a kind of personal cultural propaganda, an expansion of his or her identity onto others. A gift will remind the user of the giver, and so benefit the giver's social presence, reputation and influence. The exchange of gifts reduces the work invested in the exchanging process: since they're independent from their value, you don't have to make those calculations (labor-time). You can give spontaneously; no time is needed for complicated bargaining or agreements for return. The circulation of gifts can be compared to the rules for hospitality: giving tends to be profitable in the long run, much more than quick, impersonal acts of buying or selling (because you forget easily the face of a supermarket cashier, there's no social advantage in such a transaction). In a relatively closed, local and personalized frame, gifts will be the

ideal form of exchange of things. (This could be extended to the whole process of communication: words are also gifts… but, of course, some people count them!)

The importance of gifts will depend on the local situation. Since they tend to be spontaneous, irregular, unreliable, such *bolos* insisting on reliability and stability would use other, more conventional forms (see below). Some cultural backgrounds are less compatible with fluctuations, others more.

MAFA

The *mafa* is a socially organized system of gifts (*buni*). Its basic idea is that a common pool of reserves and resources can give participating individuals and communities more security in case of emergencies, catastrophes, temporary setbacks. Such a pool can be organized by townships, counties, etc., to help the *bolos* in moments of crisis. A township (*tega*) would have depots of basic food (cereals, oil, milk powder, etc), fuels, medicine, spare parts, clothing, etc. Any *bolo* could get such goods when it needs them, independently from its own contributions. Common pools are a kind of net under the *bolos*, should self-sufficiency fail.

This kind of common reserve with distribution according to need is in fact similar to today's systems of social security, pensions, insurance, etc. So *mafa* is the "socialist" face of *bolo'bolo*. Such systems bear the risk of creating dependencies on central bureaucracies, and thereby weaken communities.

But in the case of *mafa*, such social mutual help would be directly organized by those who can get it; it would be under local control and its size would be determined by *bolos*, townships, etc. Any abuse would be impossible, since help is always given in material forms, never in the form of money.

Help from common pools will be particularly important in the early period of *bolo'bolo*, when the damages of the past (our present) will have to be repaired. In the first place there will be many *bolos* with problems, since they are just beginning to build the basis for self-sufficiency. So free material help can help solve the problems of "transition," particularly in the Third World.

♯ FENO

Most *bolos* will need or desire a larger variety of goods than they can produce on their own. Some of these goods (or services) might even be needed on a regular, long-term basis, and for this reason simple gifts or help from common pools would not be appropriate. For this kind of regular, permanent and mutual exchange, the *bolos* will conclude barter agreements (*feno*).

Barter agreements complement self-sufficiency and reduce work, since less specialization within a *bolo* is needed, and since certain large-scale production units are more efficient and even less detrimental to the natural environment. They will be used for the exchange of necessary, basic and permanently needed goods, like foods, textiles, repair services, raw materials, etc.[21]

The number, importance and type of such agreements will vary according to a *bolo's* inner organization and its cul-

tural background. Cultural, personal or other relationships will determine the choice of a partner much more than purely objective categories (like the terms of trade, quality, distance, etc.).

To make the system of barter agreements more flexible, computer networks could be used. "Offers" could be stored in data-pools which could be consulted by others who're looking for a certain product. Quantity, quality, and optimal transportation could be calculated automatically. Such local or regional barter systems could help avoid temporary over- or under-production. With the help of more sophisticated programs, the computer could also produce prognoses and foresee impending shortages — it could make planning possible. But of course the *bolos* or other participating communities must still decide on their own whether or not they wish to connect to such a system, and whether they'll accept the computer's recommendations.

With time, the barter agreements will form a well-balanced, tightly knit and reliable network of exchange that can also continuously be adapted to changing circumstances. To minimize transportation expenditures (this is one of the main limitations of the system), exchanges of large quantities or high frequencies will be concluded among nearby *bolos*. If a *bolo* has 500 barter agreements, 300 could exist with adjacent *bolos* or *bolos* of the same township. Adjacent *bolos* could also be so intensively connected that they'll form bi-*bolos* or tri-*bolos*, or *bolo*-clusters. The more distant a *bolo*-partner is, the more refined, lighter and less frequent will be the goods concerned. From far-distant *bolos* only typically local specialties in low quantities will be exchanged (e.g., caviar from Odessa, bourbon from Louisville, tea from Sri Lanka, etc.)

Barter agreements can also exist between townships, counties or even regions, and there can also be "vertical"

bolo'bolo

bolo	tega	vudo	sumi	to Idiotropos	from Idiotropos
Quetzal	Delancey	Manhattan	Big Apple	30 pounds of rice and beans	500 foot massages
Quetzal	Delancey	Manhattan	Big Apple	bicycle repairs	200 pounds of apples
Quetzal	Delancey	Manhattan	Big Apple	10 gallons of honey	50 pounds of goat cheese
Titanic	Alphabet City	Manhattan	Big Apple	hair cutting and dyeing	5 bales of lamb's wool
Moho	Billyburg	Brooklyn	Big Apple	paintings and sculpture	plumbing repairs
Jones Hotl	Kline Road	Tompkins	New York	100 bottles local wine	20 pounds feta cheese
Bonanza	Sawtooth	Boise	Idaho Valley	3 tons of potatoes	400 pints of fresh cream
Antelope	Rosebud	Buffalo Gap	North Dakota	75 recordings of Sioux chants	75 recordings of Greek poems
Red Earth	Sun Prairie	Madison	Wisconsin	50 pounds of butter	3 lambs
Midnight	Jamaica Plain	Boston	Massachusetts	3 pounds of mushrooms	5 gallons of retsina
Malcolm	Talladega	Selma	Alabama X	40 cotton sweaters	15 pounds feta cheese
Caribou	Musquacook	Atoostook	Maine	60 lobsters, 200 pine seedlings	300 pounds quince jam
Homestead	Homestead	Amana	Iowana	ten smoke-cured hams	ten gallons olive oil
Sensevilla	Mendocino	Humboldt	California	ten kilos of marijuana	100 pounds of goat cheese
Nuvinal	Aniakchak	Aleutians	Alaska Islas	100 pounds of strawberries	large slab of marble
Geosol	Summit	Breckenridge	Coloradona	materials for passive solar plant	mosaic tiles for indoor pool
Moenkopi	Painted Desert	Kaibab	Four Corners	five silver and turquoise belts	25 pounds of cured olives
Taoa	Vava'u	Tonga	Pacific Kona	200 liters of coconut oil	3 lambs, 80 pounds feta
Pura	Jambilar	Tumkur	Karnataka	20 kilos of spices	40 liters retsina
Peredelkino	Peredelkino	Moscow	Sovietaya	75 kilos vodka, 10 tens of caviar	500 kilograms wheat flour
Celito	San Pedro	Zacatecas	Mexico Verde	100 pounds chili powder	musical instruments
Minimata	Otaru	Sapporo	Kyushu	45 cases of beer, 30 yards silk	100 liters beechnut oil
Kufra	El Derj	Jamahitraya	Cyrenaica	30 liters dates, two rugs	eight turkeys
Bishrevo	Grand Anse	St. George's	Grenada	5 liters pepper sauce	300 pears
Monterosso	Castiglione	Ombrone	Tuscano	25 pounds of spinach ravioli	20 quarts fresh cream
Mchwa	Kaskazini	Solidarnoszcz	Kosalin	100 ducks	100 bottles retsina

agreements between bolos and townships, etc. Extra-township agreements will be coordinated in order to avoid parallel transport of identical goods.

SADI

Gifts, common pools and barter agreements, combined with self-sufficiency, drastically reduce the need for economic — i.e., value-calculating — exchange. The diversity of cultural identities destroys the basis for mass production, hence also the emergence of mass marketing. The invested amount of labor-time will be difficult to compare, and exact measurement of exchange-value (through money) will be almost impossible. Nevertheless it might occur that certain *ibus* (they still have their property container, *taku*) or *bolos* could be interested in this type of calculated exchange, for certain purposes. This is the function of local markets, *sadi*. These markets complement the possibilities of exchange, determining a small part of the existential bases of *bolos*.

Under these conditions, the circulation of money is not dangerous, and it can't develop its "infecting" effects — money will remain a means only in a narrow frame.

Most townships or counties (cities) organize daily, weekly or monthly markets, regions hold periodical fairs. The townships or cities establish special halls (former factory buildings, warehouses, hangars, etc.) for their markets, so that they can also be held in winter or when it

■ gifts
▨ barter-contracts
▥ market
▭ township-depots
▢ self-sufficiency

←→ exchange-relationships

rains. Around the markets a whole series of social activities like bars, theaters, cafes, billiard halls, music halls, etc. may develop. The markets will be — as the bazaar — meeting points, spaces for social life and entertainment. Markets are at the same time "pretexts" for centers with a communicative function.

Markets will be organized and supervised by a market committee (*sadi'dala*). These committees will determine, according to decisions of the respective assemblies, what goods can be brought to the market and under what conditions. Markets are ideal for non-essential, easily transportable,

rare, durable, and highly sophisticated products. Such goods will often have a unique character, will be individual constructions, specialties, delicacies, drugs, jewelry, clothing, leather goods, works of "art," rarities, curiosities, books, programs, etc. If you need such items you cannot depend on gifts, and they're not appropriate for long-term barter agreements, either. If there is a computer databank, it might be possible to get them by using the electronic market.

As there won't be any international currencies, local markets will have their own, nonconvertible money, or maybe chips like in a casino. The single buyers or sellers will enter such a market without any money and open a credit account at the office of the market committee (again, an easy arrangement through use of computers). So they would get 100 or 1000 shillings, florins, pennies, dollars, eçus, pesos, rubles, etc. that they owe the market bank. With this money, they can buy and sell until the end of the market in the evening. Then they return their chips, and a positive or negative balance is recorded under their name until the next day, etc. These balances cannot be transfered to other markets. The accumulation of too-big balances (fortunes) can be made difficult by programming a random element into the computer, one that cancels all accounts in periods between, say, a half a year and two years (this would be a kind of electronic potlatch, or a Hebrew "jubilee"). Since there is no justice apparatus able to punish breach of contracts, any kind of business would be very risky. All this doesn't completely ban the circulation of money, because the *ibus* could still take refuge in gold or silver. In isolated townships, the local currency could circulate without any problems. It's self-sufficiency and other forms of exchange that keep money in certain limits (as was the case in the Middle Ages).[22]

FASI

Is the *ibu* a settled or a nomadic being? In its (imaginary) history it appears as steppe horseman and as builder of cathedrals, as farmer and as gypsy, as gardener and as globetrotter. The *bolos* presuppose a certain degree of settledness (because of agriculture), and a society of pure hunter-gatherers will only be possible when the world population is drastically reduced (to some million *ibus*). Nevertheless, *bolo'bolo* should bring back to every single *ibu* free movement across the whole planet. There won't be any forced settledness for nomadic *bolos* or gangs, no programs of modernization and industrialization.

A single *ibu* only feels comfortable when it can be sure that it can leave at any moment for Patagonia, Samarkand, Kamchatka, Zanzibar, Alaska or Paris. This will be possible because all *bolos* will be able to guarantee hospitality to any traveler (*sila*). There won't be lack of time (no *ibu* must be afraid for lack of money), so travel can be more leisurely. Today's immense waste of energy can be reduced because traveling won't be a question of getting as far as quickly as possible. You won't need charter flights in order to visit South America or West Africa for just three weeks. Travelers won't be stressed tourists.

The *bolo'bolo* system of transportation and traveling (*fasi*) will be oriented towards eliminating transportation of mass goods and commuters, by means of local production and living and working in the same township. Commuter

traffic, mass transportation, tourism, all will disappear; the major means of transportation will be used primarily for people who enjoy traveling. Traveling is a pleasure in itself, and there's no substitute for it. But lettuce hardly enjoys the trip from California to New York.

Since most of the *ibu's* activities take place in the *bolo* or township, most changes of place by *ibus* can be achieved on foot. The townships will be pedestrian areas with many passages, bridges, arcades, colonnades, verandahs, loggias, paths, squares, pavillions. Unhindered by traffic lights (there's almost no car traffic), the *ibu* will get around with as much ease and more simply than it can today, and wherever it wants. And above all, with little stress.

Up to the limits of the county (*vudo*) the bicycle will be the ideal means of transportation. To this purpose, townships or cities can organize bicycle pools. In combination with an *ibu*, the bicycle is the most energy-advantageous means of transport (fuel is delivered to the *ibu* in the form of food, anyway). Yet this means a well-organized system of (small) roads to be maintained. In mountainous areas, during bad weather and in winter, it is impractical. When there is enough snow the *ibu* can get around on skis.

In mountainous areas and in the country, animals are very efficient, particularly when their fodder grows right by the side of the road: horses, mules, donkeys, yaks, ponies, camels, oxen, dogs, elephants, etc. Also in cities horses and mules (less fastidious as to nutrition, but requiring more handling experience) can be useful in certain conditions. (Especially for transport between town buildings and the agricultural bases of a *bolo*, when too the fodder wouldn't have to be brought to town for them.) But in the city itself the *ibu* (+bicycle, +skis, +sled, +skates, +etc.) is the ideal means of transportation — the autonomobile.

The bicycle can also be used for transportation of small goods, particularly in the form of rikshaws or trailers. A pentadem can transport five persons and an additional 350 kilograms of cargo:

Compared to the bicycle, even such means of public transportation as trolleys, tramways or subways are relatively expensive, since they need an elaborate infra-structure (tracks, cables, wagons). But it could still be reasonable for an urban area to operate a reduced network, especially when electricity is locally or regionally available. In a middle-sized city, three transversal lines would be sufficient, since you could reach all *bolos* within an hour using a bicycle from the stops of such a tramway or bus network.

"average" city (300'000 inhabitants)

```
    1   2   3   4   5   6 km
———   by foot: 1h 10
······  by bicycle : 20 minutes
- - -  tramway+by foot: 20 minutes
-··-··  tramway+bicycle: 15 minutes
```

The street system, maintenance of which is very labor intensive (pouring asphalt or concrete, fixing potholes, etc.), can be reduced so that there is only one road to every bolo or farm. Most roads in the cities will be superfluous, and most country roads and highways can be narrowed to one or two lanes. The remaining automobile traffic will be slow and unimportant. There will still be some trucks (operated with bio-gas, steam, wood, gasoline), some buses, ambulances, fire engines, special transports.

▨ streets not used for traffic

Some motorways can be used as race tracks for entertainment. A 200 kilometer (120 miles) highway could be reserved for such purposes. At both ends car parks, where you could choose a fast sports car. Without any speed limits, the drivers could then drive back and forth between the two ends of the speedway. So those *ibus* who like driving fast and who use the car as a means of entertainment and risk could still do it. Such a speedway would be less costly than today's car traffic, in spite of expenditures for gas, ambulances, medical care, car maintenance, etc.

If the *ibu* wants, it can get by bicycle from Cairo to Luanda, from New York to Mexico City, from New Delhi

to Shanghai. But it could also take local and regional means of transportation operated by counties and regions (*sumi*). In many cases, these will be slow—railroads (steam-, electricity-, or coal-powered) that aren't terribly frequent and that stop at every station. There will also be navigation on canals, along coasts. There will be buses. What kinds of connections are available will depend entirely upon the regional communities and the geographic conditions (deserts, mountains, swamps). In an average region, you would possibly find not much more than two lines of public transportation:

```
                transcontinental railroad
```

```
                     100              200 km
    ············ - - -  A-B by train and bicycle:
                                      5 hours
```

When an *ibu* wants to travel far, it'll go to the nearest station of the intercontinental railroads, which are operated by a commission of the planetary assembly (*asa'dala*) and

which form a kind of backbone of continental transportation. The rail system would be about like this:

This transcontinental railroad network can be based on existing tracks, with only a few supplementations and adaptations. To make traveling more comfortable, the Russian broad track could be introduced. With the transcontinental railroad, the travelers can basically get from East to West and from North to South, from Helsinki to Capetown, from Lisbon to Vladivostok, from Anchorage to Rio Gallegos and from New York to San Francisco. Where the tracks end, the travelers can board ocean steamliners (Vladivostok to San Francisco, Lisbon to New York, etc.). For sea transportation, energy problems are unimportant; coal, petroleum, etc. can be easily transported on the ships themselves, and sails could be used additionally.

The planetary assembly or regional coalitions will operate international airlines, too. They're important for distant islands, for deserts, for jungles, in polar regions, etc. There will be much less need for flights than today, and flights are after all in most cases too expensive with respect to fuel and infrastructures. The lack of many of these will not be a real disadvantage, since traveling won't be a quick means to an end, but an entertainment in itself. There will be enough planes for urgent transport (ambulances, medicines, spare parts, funerals, etc.)

As all *ibus* will be able to travel (not only the rich ones, like today), tight personal relationships between distant *bolos* will develop; new ideas will spread easily, friendships, love affairs, pregnancies, projects, fancies, and cultural identities will link them. In spite of the relative slowness of traffic, planetary exchange will be more intense and generalized than today. The *ibus* from different continents will deal with each other on the same level; "tourism" will be inverted: Bantus in Berlin, Quiche Indians in Peking, Mongols in Paris, Tamils in Detroit, etc. The planet will become a mutual anthropological museum.

YAKA

Is the *ibu* a good-natured, love-starved nice being, or is it quarrelsome, reserved, violent? Is it only aggressive because the nightmare of work and repression has made it envious, frustrated and irritable? This might be true. And yet there might also be jealousy, offended pride, destructivity, antipathy, lust and murder, megalomania, obstinacy, aggressivity, towering rage, running amok. At least such desires cannot be excluded at the outset. That's why *yaka* will be necessary for *bolo'bolo*.

yaka makes possible quarrels, disputes, fights, and war.[23] Boredom, unlucky-in-love stories, madness, misanthropy, deceptions, conflicts around honor and lifestyle, even ecstasy can lead to *yakas*. They can take place between:

>*ibus* and *ibus*
>*ibus* and *bolos*
>*bolos* and *bolos*
>*tegas* and *ibus*
>*bolos* and *tegas*
>*bolos* and *vudos*
>*ibus* and *sumis*
>*vudos* and *sumis*
>etc.

Like other forms of exchange (in this case, of physical violence), *yakas* (fights) can be regulated by certain com-

mon agreements, in order to limit danger and risk. It will be one of the tasks of the township assemblies and county committees to help the *ibus* and *bolos* maintain the *yaka* code:

— A formal challenge must take place in the presence of at least two witnesses;
— A challenge can always be refused;
— The respective assemblies (*yaka*-committees of *bolos*, townships, counties, etc.) must be invited to try for reconciliation;
— The choice of weapons and of time for the duel belong to the challenged;
— The type of armor is part of the weapon;
— The duel must take place in the presence of a delegation of the respective committees;
— The respective *yaka* committee provides the weapons for both parties;
— As soon as one of the parties declares itself defeated, the fight must be stopped;
— Weapons whose range is greater than the ability to see the white of the enemy's eye are prohibited (around 100 yards);
— Only "mechanical" weapons (the body, sticks, maces, swords, slings, spears, arrows, axes, crossbows, rocks) are permitted: no guns, poison, grenades, fire, etc.[24]

The duel committees get the weapons, arrange the battleground, organize referees (armed, if necessary), take care of transportation and medication for wounded or dying, protect bystanders, animals, plants, etc.

If the larger communities (counties, *bolos*, townships, etc.) get into fights, the competent duel committees might be forced to considerable efforts. Damage caused by fights must be repaired by the challengers, even in case of victory.

Duels will almost never be linked to winning material advantages, since they're very costly and since the parties will be obliged to live together afterwards. Most motivations for duels will therefore be in the field of emotional, cultural or personal contradictions. They might serve to diminish or increase someone's reputation (*munu*). (In the case of prevalent nonviolent ideologies, diminish.)

It's impossible to predict how frequent and how violent and how extended *yakas* will be. They're a cultural phenomenon, a way of communication and interaction. As they involve many material and social disadvantages (wounds, damage, ruined reputations), they might prove to be the exception. But duels and fights are not games, and cannot simply signify the acting out or "sublimation" of aggressivity — they cannot be considered a kind of therapy; they're serious, and real risks. It is even possible that certain cultural identities would have to die without permanent or periodic fighting. Violence continues, but not necessarily history.

Notes

1. Juliet B. Schor, *The Overworked American*, Basic Books, 1991, p. 30. Manufacturing employees in the U.S. now work 320 hours longer a year than their colleagues in France or Germany.
2. These corrections are mainly based on the works of Heide Göttner-Abendroth (*Das Matriarchat*, Stuttgart, 1991) and Carola Meier-Seethaler (*Ursprunge und Befreiungen*, Arche Verlag, 1989). It seems that there is no inevitable logics of authoritarian development in agriculture.
3. The dream character of my universe (who knows another one?) isn't just a philosophical joke, but rather one of

the conclusions of modern quantum physics. There "is" no world out there to give us a "real" orientation: reality is just a rhetorical pattern. Michael Talbot (*Mysticism and the New Physics*, Routledge & Kegan Paul, 1981, p. 135) puts it this way: "In the paradigm of the new physics we have dreamed the world. We have dreamed it as enduring, mysterious, visible, omnipresent in space and stable in time, but we have consented to tenuous and eternal intervals of illogicalness in its architecture that we might know it is false." After Heisenberg, Schrodinger, Bell, etc., nobody can claim reality for himself in the name of science. Physicists like Fritjof Capra (*The Tao of Physics*, Berkeley, 1975) have betrayed Bacon's and Descartes' optimism and turn to oriental mysticism. "Reality" is a witchcraft formula, as well as "Holy Trinity." The realists are the last adherents of an old religion, charming, but naive.

4. A *bolo* isn't just a traditional neighborhood, nor a self-help network, nor a tribe. It's true that the number of its inhabitants (500) corresponds to the minimal number of members of the traditional tribe. About 500 individuals form the smallest possible genetic pool of the species *homo sapiens*. It seems that this social unit has been typical for all societies of hunter/gatherers for millions of years (i.e., well before *homo sapiens* came into being). (Richard E. Leakey and Roger Lewin, *People of the Lake: Mankind and its Beginnings*, Avon, 1979, p. 111.) So it is probable that we could feel comfortable in communities of this size. Yet, a *bolo* has many other advantages in the fields of agriculture, energy, medicine, cultural identity, etc.

The number of 500 persons seems to be a kind of upper level limit for "spontaneously" functioning larger social organisms. It corresponds to the inhabitants of

typical older urban neighborhoods in a lot of countries, to an infantry battalion, to the capacity of a larger hall, to the size of a medium enterprise, to a medium-sized school, etc. The reasons are not purely genetic or traditional. The number of 500 persons permits a minimal diversity of age, sex, interests, a basic division of work. At the same time, self-organization is still possible without special organisms, anonymity is not a necessary consequence (you can still know personally all members of the community, but without necessarily being close friends). Age groups are large enough for social interaction and even endogamy is possible. In an advanced industrialized country there would be about 200 young persons (1–30 years), 200 persons in the middle (30–60), and 100 elderly persons. Age groups (1–9, 10–19, etc.) would comprise between 20 and 40 persons (except above 80 years, of course). In Third World areas, these numbers would be different at first (300 young, 150 middle, 50 old), but later on adapt to the figures above.

It's typical for most of the alternative and utopian theorists that they conceive their basic communities from an administrative or purely ecological/technical point of view. This is also the case for anarchist or syndicalist theories and for most utopias. Thomas More, in 1516, combines 30 large households into units of about 500 persons ("Thirty households, fifteen from either side, are assigned to each hall and take their meals there." *Utopia*, Washington Square Press, 1971, p. 59.). The basic communities of the 19th-century utopians (Fourier, Saint-Simon, Weitling, Cabet, Owen, etc.) are mostly larger, because they're oriented towards pure autarky. Fourier's phalansteries are little universes containing all human passions and occupations. Most

modern utopias are in fact totalitarian, monocultural models organized around work and education. Ironically, some utopian elements have been used for the conception of prisons, hospitals, and in totalitarian regimes (fascism, socialism, etc).

In "A Blueprint for Survival" (*The Ecologist*, Volume 2, No. I, 1972, quoted in David Dickson, *Alternative Technology*, Fontana, 1974, p. 140), the basic units are "neighborhoods" of about 500 persons that form "communities" of 5000 persons and "regions" of 500,000 persons, which in turn are the basis for "nations." Callenbach (*Ecotopia*, Bantam New Age Books, 1975) proposes "minicities" of about 10,000 people and communities of 20–30 persons. In a Swiss study (Binswanger, Geissberger, Ginsburg, *Wege aus der Wohlstandsfalle*, fischer alternativ, 1979, p. 233), social units of more than 100 persons are considered to be "non-transparent," while the Hopi say that "a man cannot be a man when he lives in a community that counts more than 3000 persons." Skinner's *Walden Two* (Macmillan, 1948) is populated by 2000 persons, and the largest crowd in his system is 200 persons. See also Galtung's self-reliance communities.

Most utopias are full of general prescriptions that are compulsory in all their basic dimensions (clothing, work timetables, education, sexuality, etc.), and they postulate certain principles of internal organization (democracy, syphogrants, etc.). Reason, practicability, harmony, non-violence, ecology, economic efficiency, morality, all are central motivations. But in a *bolo* culturally defined people live together and their motivations are not determined by a compulsory set of moral laws. Each *bolo* is different. Not even a perfectly democratic structure can guarantee the expression and real-

ization of the desires of the participating persons. This is also a basic flaw of many proposals for self-administration (block councils, neighborhood-defense committees, soviets, grassroots democracy, etc.), especially if such grassroot organizations are initiated and controlled by state or party organisms. Only cultural identity and diversity can guarantee a certain degree of independence and "democracy." This is not a question of politics.

As the *bolos* are relatively large, there will be subdivisions and supplementary structures and organisms in most of them. Such problems as having (or not having) children, education (or better: no education at all), polygamy, exogamy, relations, etc. cannot be dealt with in such a large frame. These structures will be different in every *bolo* (*kanas*, families, large households, gangs, single cells, dormitories or not, totems, etc.).

For many reasons, the *bolos* aren't simply tribes — their time has irrevocably gone. The slogan "Only tribes will survive" sounds beautiful and romantic, but our unfortunate history shows us that tribes haven't survived in most parts of the world, and those that remain are still disappearing. What we know today as tribes are mostly patriarchal, crippled, isolated, defensive and weakened structures, and can serve no longer as practical models. It is true that most properties of an "ideal tribe" can be applied to the *bolo* (cultural identity + self-sufficiency + size + hospitality), but the "real" tribes have left us in the mess we have now. The tribes (that's all of us!) haven't been able to stop the emergence of the Planetary Work Machine. Once upon a time we were all good savages, yet here's this monster civilization. There's no reason to assume that the actually surviving tribal societies would have done better — they've just been spared by the circumstances. Only

today we can take care of preventing that the same "mistake" (every mistake has got to be made once in history... maybe twice...) cannot happen again. The industrial work-society was not a pure hazard; we've got to face it, learn from it, and no flight into the tribal myth will help us. The real "Tribal Age" starts just now.

Social organization always means *social control* even in the case of the flexible, loosely defined *bolos*. When money disappears as a means of anonymous social control, this control will reappear in the form of personal, direct supervision, interference, constraint. In fact any form of solidarity or help can also be considered as a form of social constraint. Every *bolo* will have to deal with this inevitable dialectics of constraint and help in a different way. Personal social control is the "price" we pay for the abolition of money. Almost nobody will be able to isolate him or herself and to disappear in the anonymous interstices of a mass society like the present, except in those *bolos* based on conscious anonymity. Society always means police, politics, repression, intimidation, opportunism, hypocrisy. For many of us, society will never be supportable and a "good society" is the name of our nightmare. For this reason *bolo'bolo* cannot be a homogenous system for everybody — there will be left-over spaces for small groups, singles, bums, hermits, etc. Not everybody can live in society. (This aspect is also missing in most utopias or political ideologies — except in good old liberal philosophy. *bolo'bolo* is closer to liberalism than to socialism... but liberalism alone is as totalitarian as socialism: the ideology of the dominant.) I'm afraid of *bolo'bolo*....

5. It depends on local conditions and on the methods used how much land will be needed to feed a *bolo*. According to the data of the Food and Agriculture Organization

(F.A.O.), 100 square meters (119 square yards) per person, i.e. 12.5 acres per *bolo* are sufficient (Yona Friedman, *alternatives énergétiques*, editions dangles, 1982, p. 63). If we take John Seymour's figures (*The Complete Book of Self-Sufficiency*, Dorling Kindersley, 1976), we'd need four acres for a "large family" (ten persons?), i.e., 200 acres for our *bolo* (in a moderate or cold climate). Seymour's approximations seem to be more realistic, but they're calculated on the basis of a very small, extremely diversified farm, thus are rather high. But even with these figures, self-sufficiency can be attained under unfavorable conditions, e.g., in a small country like Switzerland with little arable land. (Today this country attains only 56% self-sufficiency in food production.) Under better conditions, like China, South Korea, or Taiwan, less arable land per capita is needed (.32 acres, .17 acres, .14 acres respectively). Under optimal conditions and methods (as in the case of Taiwan) 74 acres per *bolo* are sufficient. Under the assumption that 39 grams of protein (animal and vegetable) per day and 285 pounds of grains per year per person guarantee adequate nutrition, all existing countries except Liberia and Zaire are capable today of producing enough food for their inhabitants. (Frances Moore Lappe, Joseph Collins, *Food First: Beyond the Myth of Scarcity*, New York, 1977). Thus, self-sufficiency is not a problem of lack of land or overpopulation, but of organization, methods and local control over agricultural resources.

For future *bolo*-builders the following figures (provided by actual farmers producing in the temperate climate of Switzerland) might be useful:

For vegetables (2 kg per person per week) allow 2.5 ha

For milk, yogurt, cheese, butter: 60 cows on 30 ha

> For eggs (4 per person per week): 500 hens on 5 ha
> For bread and pasta: 15 ha
> For potatoes (1 kg per person per week: 1 ha
> For fruit, berries, cider: 8 ha
> For meat: 931 kg per year, half of today's consumption: 22.5 ha
>
> To feed 500 persons with a balanced *non*-vegetarian diet: 85 ha (210 acres). In switzerland (a worst-case scenario compared to the US) there are actually 89 ha per virtual *bolo*, plus pastures, forests, etc. in the US there is absolutely no problem of available land. (P.M. and friends, *Olten–alles aussteigen*, Zurich, 1991, p. 64).

6. The idea of money as a "simple and practical" means of measurement for exchange is very common among utopians and alternativist theorists. Some of them complain only about excesses like inflation, the formation of huge fortunes, its "abuse" for capitalist goals, and they dream of the re-establishment of money as a solid measure for work. It is typical that the American utopianist Callenbach doesn't seem to be aware of the fact that dollars keep circulating in his *Ecotopia* just as they did before. It is nonsense to propose a system of direct, personal and ecological exchange and to permit at the same time the vehicle of anonymous, indirect, centralized circulation (money). Money as a general means of measurement presupposes mass-production (only in this case are goods measurable and comparable), a centralized bank system, mass distribution, etc. It is exactly this basic anonymity and non-responsibility of everyone for everything that causes and permits all those mechanisms of destruction of nature and people. As Callenbach poses these mechanisms as a moral problem (respect for nature, etc.), he needs a (very sympathetic, very democratic, even feminized) central

State (The Big Sister) to repair the damage done by the system, through price controls, regulations, laws and prisons (of course, these latter only "training camps"). What he allows economically he has to forbid politically: the space for morality is opened. (Thou shalt not....) As for the restricted use of local currencies in *bolo'bolo*, see *sadi*.

7. *sila* is nothing new, but rather a return to the old "laws" of tribal hospitality that have been functioning for thousands of years, much longer than American Express, Visa or Master Card. In most advanced industrialized countries hospitality is in crisis, because the nuclear family is too weak to guarantee it on a long-term basis. In its origins, hospitality has never been considered as a kind of philanthropy, but was rather born out of fear of the stranger: he had to be treated in a friendly manner to prevent misfortune brought upon the clan or tribe. If the number of guests surpasses a certain level for a longer period of time, friendliness declines and a certain amount of travelers is balanced out automatically (to about 10%). *sila* is a self-regulating, feedback process of exchange.

8. The *kana* corresponds to a gang of hunter/gatherers which, according to Leakey, has been the everyday community of mankind (even before *homo sapiens*) for millions of years (see note 4). Considering that we (including everybody, from the metropolitan-neon-Zen-cocaine-single intellectual to the Australian aborigine) have been roaming through the country in groups of 25 people for millions of years and that only for the last few thousand years have we been living in families, villages, towns, practicing agri- and fabri-culture, we can assume that the *kana* is something we still have in common. (In any case, it is more "natural" than the nuclear family.)

Like the *bolo*, the *kana* is a universal social form providing a common basis across all cultural barriers.

The patriarchized *kana* is still alive in different metamorphoses: school-classes, infantry platoons, clubs, party cells, circles of intimate friends, etc., and has thus exerted its paleolithic charms in the work-society. With *bolo* and *kana*, we go back very far (50,000 years) to get strength for this big jump. Consciously exploited traditions are the basis for future wealth. (Traditional societies usually don't even know that they have these traditions, much less what they're good for.)

9. The *bolos* are not primarily ecological survival systems, for if you only want to survive it's hardly worth it. The *bolos* are a framework for the living-up of all kinds of life styles, philosophies, traditions and passions. *bolo'bolo* is not a life style in itself, but only a flexible system of limits (biological, technical, energical, etc.). As for the knowledge of such limits, ecological and alternativist materials can be quite helpful, but they should never serve to determine the content of the different life styles. (Fascism had its biological ideological elements....) At the core of *bolo'bolo* there's *nima* (cultural identity) and not survival. For this same reason, *nima* cannot be defined *by bolo'bolo*, it can only be lived practically. No particular "alternativist" identity (health foods, earth shoes, woolen clothes, Mother Earth mythology, etc.) is proposed.

The crucial function of cultural identity is illustrated best by the fate of the colonized peoples. Their actual misery didn't start with material exploitation, but with the more-or-less-planned destruction of their traditions and religions by the Christian missionaries. Even under present conditions many of these nations could be better off — but they just don't know anymore why

they should be, or what for. Demoralization goes deeper than economic exploitation. (Of course, the industrialized nations have been demoralized in the same way — it just happened longer ago and has become part of their standard cultures.) On Western Samoa there is no hunger and almost no disease, and the work intensity is very low. (This is due mainly to the climate and to the rather monotonous diet of taro, fruits and pork.) Western Samoa is one of the 33 poorest countries in the world. It has one of the highest suicide rates in the world. Mostly those killing themselves are young people. These suicides are not due to pure misery (even if it cannot be denied that there is misery), but to demoralization and the lack of perspectives. The Christian missionaries have destroyed the old religions, traditions, dances, festivals, etc. The islands are full of churches and alcoholics. The paradise had been destroyed long before the arrival of Margaret Mead. In spite of some vulgar-Marxist conceptions, "culture" is more important than "material survival," and the hierarchy of basic or other needs is not as obvious as it might seem, but rather "ethnocentric." Food is not just calories, cooking styles are not luxuries, houses aren't just shelters, clothes are much more than body insulation. There's no reason why anybody should be puzzled if people who are about to starve struggle for their religion, their pride, their language and other "superstructural" "fancies" before they demand a guaranteed minimal wage. It is true that these motivations have been manipulated by political cliques, but this is also the case with "reasonable" economic struggles. The point is, they exist.

Where should the *nima* come from? It is certainly wrong to look for cultural identities exclusively in old ethnic traditions. The knowledge and rediscovery of such

traditions is very useful and can be very inspiring, but a "tradition" can also be born today. Why not invent new myths, languages, new forms of communal life, of housing, clothing, etc.? One's traditions can become another's utopia. The invention of cultural identities has been commercialized and neutralized in the forms of fashion, cults, sects, "waves" and styles. The spreading of cults shows that a lot of people feel the need for a life governed by a well-defined ideological background. The desire that is perverted in the cults is the one of unity of ideas and life — a new "totalitarianism" ("Ora et labora"). If *bolo'bolo* is called a kind of pluralist "totalitarianism," that's not a bad definition. It can be said that since the 1960s a period of cultural invention has begun in many — especially industrialized — countries: oriental, Egyptian, folk, magical, alchemical and other traditions have been revived. Experimentation with traditional and utopian lifestyles has begun. After having been disappointed by the material riches of the industrial societies, a lot of people have turned to cultural wealth.

Since the *nima* is at the core of a *bolo*, there can't be any laws, rules, or controls over it. For the same reasons, general regulations on work conditions inside the *bolos* is impossible. Regulated working time has always been the central showpiece of utopian planners. Thomas More in 1516 guarantees a six-hour day, Callenbach a 20-hour week, Andre Gorz (*Les chemins du Paradis — l'agonie du Capital*, galilee, 1983) proposes a 20,000-hour work life. After Marshall Sahlins' research on *Stone Age Economics* (1972), the two- or three-hour day is about to win the race. (Ironically, it turns out that the US standard of living of 1948 could today be reproduced in four hours per day... utopia is *behind* us. Cf. Schor, footnote 1.) The problem is who should en-

force this minimal working time, and why. Such regulations imply a central State or a similar organism for reward or punishment.

Since there is no state in *bolo'bolo*, there can't be any (even very favorable) regulations in this field. It is the respective cultural context that defines what is considered as "work" (=pain) in a certain *bolo* and what is perceived as "leisure" (=pleasure), or if such distinction makes any sense at all. Cooking can be a very important ritual in one *bolo*, a passion, while in another *bolo* it's a tedious necessity. Maybe music is more important in the latter, whereas in another *bolo* it would be considered noise. Nobody can know whether there will be a 70-hour work week or a 15-hour work week in a *bolo*. There is no obligatory life style, no general budget of work and leisure, just a more-or-less free flow of passions, perversions, aberrations, etc.

10. Why not choose an existing international language like English or Spanish? It's impossible, because such languages have been the instruments of cultural imperialism and tend to decompose local traditions and dialects. The institution of standardized "national" languages in the 16th and 17th centuries was one of the first steps of the young bourgeoisie in making transparent the emerging factory proletariat: you can only enforce laws, factory regulations, etc., if they're understood. Misunderstandings or "being stupid" were in fact among the earliest forms of the refusal of industrial discipline. The same "national" languages have later become instruments of discipline on an imperialist level. *bolo'bolo* means that everybody "gets stupid" again....

Even so-called international languages like Esperanto are modeled on western European "national" languages and linked to imperialist cultures.

bolo'bolo

The only solution is a completely random, disconnected, artificial "language" without any cultural links.

So *asa'pili* has been dreamed up by the *ibu*, and no etymological or other research will be able to explain why an *ibu* is an *ibu*, a *bolo* a *bolo*, a *yaka* a *yaka*, etc.

asa'pili is composed of a gang of 18 sounds (plus pauses) found in many languages in different variants.

In English they sound like this:

vowels: a "ah" ("farm")
 e "ey" ("pet")
 i "ee" ("see")
 o "oh" ("port")
 u "oo" ("poor")

consonants: p, t, k, b, d, g, m, n, l, s, y, f, v

(pronounced as in English)

"l" can also be pronounced like "r," aspirated and non-aspirated sounds, open or closed vowels are not distinguished; accent is free.

asa'pili words can be written with signs (see the list in this book); no alphabet is needed. In the English edition of this book, Latin characters are only used for convenience — other alphabets (Hebrew, Arabic, Cyrillic, Greek, etc.) could also be used.

The doubling of a word indicates an organic plural: *bolo'bolo* = all *bolos*, the system of *bolos*. With the apostrophe (') composites can be formed at will. The first word determines the second (as in English): *asa'pili* ("world language"), *fasi'ibu* ("traveler"), *yalu'gano* ("restaurant"), etc.

Besides this small *asa'pili* (containing only about thirty words) there could be created a larger *asa'pili* for scientific exchange, international conventions, etc. It will be up to the planetary assembly to put up a dictionary and a grammar. Let's hope it will be easy.

11. The present and permanent planetary hunger catastrophe is caused by the fact that production and distribution of food isn't under the control of local populations. Hunger is not a problem of local production, but rather is caused by the international economic system. Even under present conditions there are 3000 calories of cereal grains per day for everybody, and additionally the same amount in the form of meat, fish, beans, vegetables, milk, etc. The problem is that large, poor masses of people just cannot buy their food (and after their own bases of self-sufficiency have been destroyed). All the talk about over-population and population control is just a strategy of diversion from the real, political, problem. If 100% of the world population lived at the level of those 85% that are now poor, this planet could feed and sustain forty billion people. The ecological ruin of the planet is mainly caused by those 20% of the world population using 80% of the energy and other resources. Good advice to the South to make fewer babies is not in order, and just another proof of Western arrogance and cynicism. (One baby born in the US consumes 120 times more energy than his Ugandan colleague, so we'd rather *learn* from the Ugandans how *they* cope....)

Monocultural, large-scale agro-industries and mechanized animal production seem to be more efficient and productive, but in the long run they lead to soil erosion and the waste of energy, and they use up for animal-protein production a lot of vegetable foods that are needed for feeding people. Local self-reliance (with moderate self-determined exchange) is possible practically everywhere, and is even safer due to more careful use of the land. (So the methods of the Amish in Pennsylvania are more promising for the US in the

future than the dominant ones.) It's obvious that this doesn't simply imply the return to traditional methods (which have failed in many regions). New knowledge in the field of biodynamic methods and the intensive combination of different factors (crops + animals, animals + methane production, alternation of crops, etc.) is indispensable for a new start.

12. This three-zone model is based on ideas of the German urban ecologist Merete Mattern. A 15-kilometer-sized agricultural zone could feed such a large city as Munich. For this purpose, she proposes two forest zones (for a good micro-climate) and an intensive compost system. This means that agricultural self-reliance is also possible in densely populated areas. But this would imply that every square foot is used, and that there be no space for waste, experimentation or parks. A more flexible system of three zones and additional farms would be more practical, as distance, required freshness and harvest-cycles could be optimally combined. (You're not going to grow wheat in your backyard and plant parsley out of town....)

13. Soya, corn, millet and potatoes can guarantee minimal alimentation, but alone they do not represent a healthy type of nutrition. They've got to be combined with meat, vegetables, eggs, fats, oils, cheese, herbs and spices. Soya yields 33% more protein per surface unit than any other field crop. In combination with wheat or corn, the use of this protein is 13–42% more efficient. Soya can be used for a wide spectrum of derivative products: tofu, soya-milk, soya curd, tofu-powder, okra, yuba, soy sauce, soy flour, etc. In Africa the *niebé* bean is almost as practical as the soy bean. (Albert Tévoédjrè, *La Pauvreté — Richesse des Peuples*, Les Editions Ouvrières, Paris, 1978, p. 85.) One of the initial problems of local self-re-

liance based on these crops will be to reintroduce the regional genetic seed-material that has been replaced by industrial products which are very unstable and vulnerable.

14. Alternative or soft technology is nonsense if it's considered independently from specific social structures. A single house full of solar collectors, wind mills and other gadgets is just a type of new and very costly hobby. Soft technology without "soft society" means just the opening of a new market for big industries (as is already the case with home computers) and the birth of a new type of home-industry. *bolo'bolo* won't be high tech, electronic, chemical and nuclear, because these technologies don't fit into a fragmented, "irresponsible" system. If there are factories, they'll seldom count more than 500 workers. But it's certainly possible that for selected products one or two huge factories per region or continent will remain: for electronic raw materials, gasoline, basic chemical substances, etc.

15. In fact, agriculture and fabriculture (*kodu* and *sibi*) are just two types of energy supply (*pali*): *kodu* provides high-grade energy for people, *sibi* lower-grade energy for secondary applications. The question of the realizability of *bolo'bolo* can be reduced to the energy problem. Theories, conceptions, and technologies for alternative energy production have been developed abundantly in the last ten or fifteen years (Lovins, Commoner, Odum, Illich, etc.). Most alternative energy theorists also insist on the fact that energy supply is not a merely technical problem, but concerns the whole of a way of life. But for real-political reasons such contexts are often concealed or minimized. This is, e.g., the case in the study by Stobaugh (Stobaugh and Yergin, eds., *Energy Future: Report of the Energy Project at*

the Harvard Business School, New York, 1979). With the help of conservation and improvement of engines and generators (co-generators of heat and electricity) the authors promise energy savings of about 40%, without any changes in the standard of living or economic structures. Whereas the basic energy needs are not criticized, different technical and organizational measures are proposed to solve the problem. To a certain degree this is also true for Commoner's methane-gas strategy (combined with solar energy): the approach is mainly technical (political only in the sense that it means opposing the petroleum multinationals), and the energy system is still conceived independent from social changes. (Commoner wanted to be elected US President in 1980.) The individual car, big industry, individual nuclear-family households, etc., are not attacked. In the US, 58% of the whole energy supply is used for heating and cooling, 34% for fuels (cars and trucks), and only 8% for those special applications where electricity is specifically needed. (Fritjof Capra, *The Turning Point*, 1982.) Most energy is used for traffic and for double and triple heating (the consequence of the separation of housing and work space). Under *bolo'bolo* conditions it should be possible to reduce the overall energy needs to about 30% of today's amount. (Friedman, cited in note 5, gets roughly the same figure for his "modernized farmers' civilization.") A thus-reduced energy need can be produced by hydroelectricity, solar and geothermic energy, solar cells, the warmth of lakes and seas (using pumps), methane from bio-gas, hydrogen from algae, wind generators, wood, some coal and petroleum. Though coal is available in huge quantities and has been sufficient for many centuries, there are grave arguments against its expanded use: the carbon

dioxide problem, the rain, the dangers of mining, the destruction of landscapes by strip-mining, transportation costs, etc. There won't be a "coal age" nor a "solar age," but a network of carefully adjusted, small, diversified, locally adapted circuits that reduce the overall energy flow. Even the production of solar energy on a large scale requires considerable industrial investment (metals, tube systems, collectors, storage equipment, electric and electronic installations, etc.) which in turn can only be produced with high-energy expenditures and involve permanent control work. "Decentralization" doesn't necessarily mean independence from big industrial producers — as the example of the "decentralized" automobile from the "centralized" railroad shows. Alternative energy systems alone risk introducing a new type of decentralized industrial home-work, as was the case in the 19th century. Even an alternative energy flow (without much damage to the environment) might force us to contemplate permanent vigilance and discipline, leading to the selection of controllers and hierarchies. It could preserve nature, but ruin our nerves. There's no other solution than an absolute reduction and diversification of the energy flow by new social combinations and life styles.

It would be perverse to consider the reduction of energy supply as a kind of renunciation. (This is done by Jeremy Rifkin, *Entropy*, New York, 1980.) Using energy always means work. High energy use hasn't reduced work, it has only rationalized work processes and transposed efforts in the field of psycho-sensorial work. Only a very small part of energy use goes to replace muscle efforts. (And even these latter are not disagreeable *per se*, but only when they become monotonous and one-sided. In sports, they're consid-

ered a kind of pleasure.) With the exception of transportation, only a few pleasures are derived from a high non-human energy expenditure. For this reason, the means of transportation of people will be oriented toward pleasurable purposes (see *fasi*). A lot of ecologists have trouble imagining a civilization of non-energetic pleasure, and consider energy reduction a kind of penance (towards nature), even a form of *askesis*, a punishment for our "hedonism." Of course this would be the case if we accept energy-saving policies without insisting on new, low-work / high-pleasure life styles. Have they forgotten that the most important pleasures need almost no additional non-human energies: love, dancing, singing, drugs, eating, trances, meditation, lying on the beach, dreaming, chatting, playing. massage, bathing…. Maybe they're fascinated by the mass-consumption culture, preaching an age of renunciation in order to dominate their inner demons? Indeed, energy-saving is a moral problem if social conditions aren't attacked at the same moment. (Morality is everything you're inclined to do, but you shouldn't.)

The industrial energy flow destroys our best pleasures because it sucks up our time — time has become the greatest luxury of the moment. Energy eats up time that's needed for its production, its use, its domination and control. Less (external) energy means more time and inner energy for (old and new) pleasures, more love in the afternoon, more *savoir-vivre*, more refinement and human contacts. The prophets of sacrifice will be deluded: we won't be punished for our "sins"; we'll enter the low-energy paradise with pitch-black (ecological) souls.

As the overall energy consumption for mechanical uses will be very low, there will always be enough en-

ergy for heavy work, for agriculture, for machines. Agriculture presently uses up only 1%–3% of the energy supply (i.e., the actual, industrialized mechanized form of agriculture). There won't be an age of drudgery.

16. War and medicine, violence and disease, death from outside or from inside: these seem to be the absolute limits of our present existence. We're as afraid of "the others" as we are of our own bodies. And that's why we put our confidence in the hands of respective specialists and sciences. Since we've been made incapable of understanding the signs of our body (pain, disease, all kinds of "symptoms"), medicine has become the last science with more-or-less intact legitimation. Practically every technological leap (with the most catastrophic implications) has been justified by possible medical uses (nuclear energy, computers, chemistry, aviation, space programs, etc.). Life is posed as an absolute, ideologically and culturally independent value. Even the most brutal totalitarian regime that's able to lengthen the average life expectancy of its people gets a point. As long as we're not able to understand our body, deal with it on the basis of our own cultural identity, we'll be dependent on the medical dictatorship, on a class of priests that can virtually define all details of our lives. Among all institutions, hospitals are the most totalitarian, hierarchical, intimidating. If life (in the biomedical sense) is our main value, we ought to be building up huge medical complexes, install intensive treatment equipment in every apartment, provide artificial organ banks, life-sustaining machines, etc. These industrial efforts could eat up all of our energy and time: we could become the slaves of optimal survival. Culture is also a form of dealing with death — of building pyramids instead of hospitals (the Egyptians

weren't just crazy). Cemeteries, shrines for ancestors, funerals, these aren't a mere waste of energy and material: they save lives (against the life-industry). If we're not able to accept death in one form or another, we'll continue to kill or be killed. (You cannot be for "life" and against the nuclear holocaust in the same moment.)

17. The most dramatic consequence of our health-care system, where both families (or their rudiments)and big institutions fail, can be seen in the misery of the AIDS-patients. Needless to say that *bolos* would be the ideal places to take care of AIDS-patients, to share the necessary work and to keep these patients integrated into life. This doesn't mean, though, that I'm recommending to "wait" for *bolos* and to leave them alone at the moment. On the contrary, it might help to motivate some people to participate in AIDS-projects knowing that community efforts for these can also be seen as a type of substruction anticipating exactly *bolo*-like patterns. Actually one of the few really-existing *bolo*-like communities I've heard of so far was a lepers colony in Nigeria...) Like its counterpart — allergies — AIDS seems to be one of the symptoms of massified society lacking balanced levels fo social exchange and communication. Whereas the increasing allergies indicate a rebellion against the demand of constant "readiness" for contacts, the revolt of over-stressed social terminals that are destroyed by exaggerated defense, AIDS is the collapse of other terminals that were only too ready to "participate" and couldn't withstand external impacts. Both over-communication and under-communication are destructive. In a sense (and considering all ecological and economic effects) primary social units like *bolos* are also the answer to allergies and immune deficiencies.

18. Actually the Greek term *demokratia* designates the rule of the *demes*, which doesn't mean the population, but the clans of citizens, originally tribal units owning their land for autarky in food (pretty much of *bolo*-type, except that there was slavery, of course). Outside the *deme* there was no citizenship, *autarkeia* being the condition of political sovereignty. Since then, all systems of *laiokratia*, "ruling of the masses," have proved to be fake or extremely shaky and prone to manipulation by the really sovereign classes. After all, Hitler was elected....
19. The conversion of some US monster-cities like Los Angeles (L.A. is a lovely city!) from car to bicycle areas and from mass distribution to self-reliance looks to be an impossible task. But it is less problematic than the conversion of many European cities; at least in L.A. the population is not so dense: there's many single-family houses, large backyards, a lot of streets (which can be used for other purposes). For Los Angeles there exist already plans that foresee the condensation of neighborhoods, the establishment of supply centers, the use of free space for agriculture, etc. De-urbanization is not a process that has to be enforced — it's happening anyway in most industrialized countries, and is mainly hindered only by the present job and housing situations.

The problem is more difficult to solve in Third World metropolitan agglomerations like Mexico City, Lagos, Bombay, etc. These areas are extremely densely populated by slums, and the villages are incapable at present of receiving the returning masses. De-urbanization is these regions must start with modernization of villages so that they're attractive from a cultural point of view, as well as able to feed inhabitants. Centralized, state-enforced "solutions" can easily result in catastrophes, as in the case of Kampuchea. One of the condi-

tions for a modernization of villages is the improvement of communication systems. On the other side, a lot of slum technology can serve as a basis for self-reliance, especially in the field of recycling and efficient re-use of waste materials. (cf. Friedman, note 13.) A good example of how a large metropolitan area can be efficiently linked to the surrounding region could be Shanghai, where fresh vegetables are available on a daily basis everywhere.

20. In these times of rising nationalism, it seems almost suicidal to talk about the abolition of nations. As we're told by Marxist theorists of liberation that nationalism is a necessary step in the struggle for independence and against imperialism, this proposal seems to conceal a new imperialist strategy. This would indeed be true if only small nations gave up their existence, while the huge imperialist super-nations continued to exert their power. Abolition of nations means in the first place the subversion and dismantling of the United States and the Soviet Union, the abolition of the two blocs; without this, everything else would be pure *art pour l'art*. There are centrifugal tendencies in both superpowers, and this decomposition should be supported by any means. The main element of anti-nationalism is not a kind of pale internationalism, but the strengthening of regional autonomy and cultural identity. This is also valid for small nations: the more they start repressing their cultural minorities for the sake of "national unity," the weaker they will be and the more central the super-powers will remain. (We also must consider representations of concrete hope for the oppressed minorities in the super-nations.)

A lot of mistakes have been made concerning the so-called question of "nations." The socialists believed in the overcoming of nationalism by the development of

an internationalized modern industrial civilization, and considered cultural autonomy an excuse for backwardness. Confronted with this socialist "utopia," most national working-classes have preferred reactionary nationalism. Fascists, bourgeois parties, nationalistic regimes were able to exploit the fears of the working-classes of a socialist world-state that would take away even their small spaces of ethnic tradition. The working-classes also have come to realize that this socialist "modernism" was another name for a more perfect Planetary Work Machine.

The problem is not nationalism, but *state-ism*. There's nothing wrong with speaking one's own language, insisting on traditions, history, cuisine, etc. But as soon as these needs are linked to a hierarchical, armed, centralized state organism, they become dangerous motivations for chauvinism, the despising of diversity, prejudice — they're elements of psychological warfare. To call for a State in order to protect one's own cultural identity has never been a good deal: the costs are high and the same cultural traditions are perverted by its influence. Ethnic cultures were almost always able to live peacefully together as long as they kept States at a distance. Jewish and Arab communities have been living together without major problems in Palestine, in the Marais, even in Brooklyn, so long as they didn't try to organize into states. Of course it's not the Jews' mistake to try the idea of their own state; their communities in Germany, Poland, Russia, etc. had been attacked by states, and they had "no choice" but to organize in the same way. State-ism is like an infectious disease. After the establishment of the state of Israel, the Palestinians now have the same problem the Jews had in Germany. It's "nobody's" fault — but the

problem remains. No solution lies in asking who started it; neither a Jewish or Palestinian state can solve it, and no real-political instruments seem to be in sight. Some autonomous regions (*sumi*) with counties or *bolos* of Jews, Arabs, Druse, and others could solve the problem, but only if it's solved the same way all over the world. What's happening in the Near East now can happen everywhere at any moment. Beirut is just a dress rehearsal for New York, Rio, Paris, Moscow....

21. *feno* is an exchange system without the circulation of money. This doesn't necessarily prevent it from being subject to economic logic. To the same degree as barter partners take into account in their exchange proportions how much working time is contained in the objects, *feno* gets completely economized, and could as well be performed more efficiently again with money. That's why there are in the United States (under the impact of recessions) computerized barter-firms, making business on a billion-dollar level (for 1982: $15–$20 million) without moving a single dollar. Besides tax fraud, these systems have a lot of advantages, but remain completely inside the economic framework. Another way of barter is practiced by some people in a small region around Santa Rosa, north of San Francisco: they work for each other, get a check for their working time, and can make up to 100 hours of "debts." An office then coordinates these mutual services. Such co-op systems are also known from the Depression of the '30s. Though no money circulates, the exchange remains entirely economic, for in fact there's no difference whether you write on a piece of paper "1 hour" or "1 dollar" — maybe the graphics are more sophisticated in the latter case. Bartering might reduce anonymity to a certain degree, preventing some excesses in the

money economy, but it doesn't mean its abolition. Only in combination with cultural values, and due to a high degree of self-sufficiency, can bartering be prevented from becoming an important economic element. Barter exchanges in *bolo'bolo* will mostly come into being because two *bolos* have something in common on the cultural level: common relations, religions, music, food, ideologies. Jews, e.g., buy their food only in Jewish stores, not because it's cheaper or better, but because it must be kosher. A lot of goods will be culturally determined already, due to the way they're produced, and can only be useful for people with the same cultural preferences. Since there won't be much mass production, there won't be anonymous mass distribution and marketing. Exchange will be uneconomic, personal; the comparison of invested working time will be secondary. Since these conditions do not exist today, there are now no real *fenos*. The measurement of necessary working time will become almost impossible, since waged labor will be abolished and there won't be any adequate measurement of socially necessary labor for a given product. (How can you know how much work is needed "effectively" for a given production process if this process takes place in manifold and incomparable forms? Without big industry there is no safe value.) Value will always be around as long as there is social exchange, but under certain circumstances it can become unstable, inexact, unimportant.

22. In some utopias or alternativist conceptions we find illusionary money systems which imply that with different forms of money the problems of monetary excesses could be solved. So-called work-money (work-time instead of marks, francs, dollars, etc.) is just plain money (as Marx showed in the case of Owen's system). The

prohibition of interest, or self-depreciating money (as proposed by the Swiss Silvio Gesell), or the exemption of land from property, all presuppose a powerful central State to control, punish, coordinate: in other words, the continuation of social anonymity and basic irresponsibility. The problem is not money (or gold, or silver) but the necessity or desirability of economic exchange in a given social context (see note 21). If such an exchange is desirable, there will be money (or electronic accounts, or chips, or just memory). As economic exchange is minimized in *bolo'bolo*, money can't play an important role. (It won't have to be prohibited; who could do it, anyway?)

23. Since the *ibu* has emerged, we've gotten rid of "man," and, luckily, gotten rid at the same time of all those questions like: is "man" violent or non-violent, is he "good" or "bad" by "nature" (we've gotten rid of "nature," too). All these definitions of that strange being called "man" — particularly the humanistic, positive ones — have always had catastrophic consequences. If "man" is good, what shall we do with those who are (exceptionally, of course) bad? The historic solution has been to put them into camps and "re-educate" them. If that fails — they've had their chance, after all — they were put into psychiatric hospitals, shot, gassed, or burned. Thomas More knew "man," but he wanted to punish adultery with the death penalty in his humane utopia. We prefer not to know. So the *ibu* can be violent, it can even get pleasure out of direct, personal attacks on other *ibus*. There are no normal *ibus*.

It is pure demagogy to explain the phenomenon of modern wars by the existence of interpersonal violence. Nothing is more peaceful, non-violent, and gentle than the inside of an army; soldiers help each other, share

food, support each other emotionally, are "good comrades." All their violence is manipulated, focused on an enemy. Even in this case feelings are not very important. War has become a bureaucratic, industrialized, anonymous procedure for mass disinfection. Hatred and aggressivity would only disturb the technicians of modern war, could even prevent them from making war. War is not based on the logic of violence, of feeling, but on the logic of statehood, economies, hierarchical organization. In its form it can better be compared to medicine: the unemotional dealing with dysfunctional bodies. (Compare the common terminology: operations, theaters, interventions, disinfections, surgical strikes. And the parallelism in hierarchies.)

But if under the term "war" collective, passionate, direct violence is meant, *yaka* is a way of making it possible again. Possible, because it won't be necessary and therefore can never assume catastrophic dimensions. Maybe for similar reasons Callenbach introduces a kind of neolithically styled war-ritual in his *Ecotopia* (p. 91). But this takes place outside of everyday life and is a kind of officially supervised experiment. "Real" wars, as are possible with *yaka*, are not compatible with Ecotopia: what are they afraid of? And of course women are excluded from his war games, because they're nonviolent by nature. Another typically male myth....

24. But will such a set of war rules be respected? Won't "violence" just sweep away all inhibitions and rules? This fear is typical for a civilization where direct violence has been banned for centuries in order to preserve bureaucratized state-violence. Since violence will be an everyday experience, people will learn to deal with it in a rational way. (The same is true for sexuality, hunger, music, etc.) Rationality is linked to redundancy: events

that occur seldom lead to catastrophic reactions. War rules were effective in the times of the ancient Greeks and Romans, in the Middle Ages, among American Indians, in many other civilizations. Only under the influence of poor communications among peoples could catastrophes like Caesar, Genghis Khan, Cortez, etc. occur. *bolo'bolo* will exclude such historic accidents: communication will be universal (telephone, computer networks, etc.) and the rules will be known.

Of course, complications are possible. The enforcement of the rules can make necessary temporary militias, e.g., if a party keeps breaking them. Such militias could develop an interior dynamic and become a kind of army, which in turn would require stronger militias to control them. But such escalation presupposes a centralized economic system with adequate resources and socially "empty" spaces where it can develop. Both conditions will be lacking.

It's also imaginable that an isolated passionate tinkerer builds an atomic bomb in a deserted factory basement and is about to destroy a whole township or county while realizing his sacrosanct *nima* (cultural identity). He'd have some problems getting the necessary materials without becoming suspect to the other people around him. Spontaneous social control would prevent the worst. But even a crazy tinkerer would be less dangerous than today's scientists and politicians....